IMAGES
of America

OLD ROUTE 7
ALONG THE BERKSHIRE HIGHWAY

D1073660

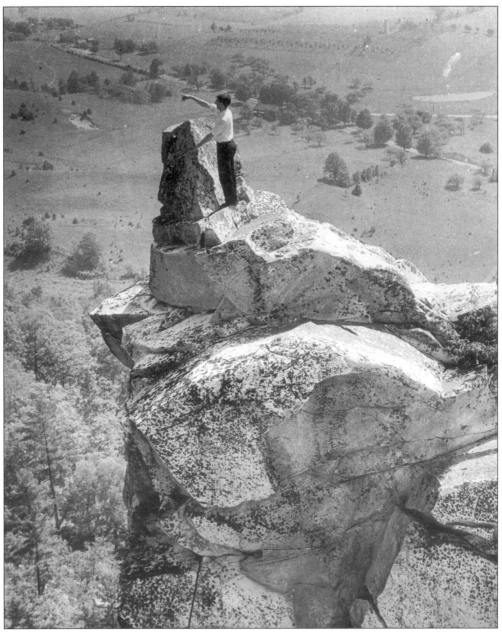

"Look, everybody! Route 7 is that way!" High atop Monument Mountain in Great Barrington, an enthusiastic hiker enjoys the view in the 1940s. The valley below offers no hint of a future where Fox Farm fields became athletic fields for Monument Mountain Regional High School. (Arthur Palme photograph courtesy of the Stockbridge Library Association.)

IMAGES
of America

OLD ROUTE 7
ALONG THE BERKSHIRE HIGHWAY

Gary T. Leveille

ARCADIA

First printed in 2001.

Published by Arcadia Publishing,
an imprint of Tempus Publishing, Inc.
2A Cumberland Street
Charleston, SC 29401

Printed in Great Britain.

Library of Congress Catalog Card Number: 2001086464

For all general information contact Arcadia Publishing at:
Telephone 843-853-2070
Fax 843-853-0044
E-Mail sales@arcadiapublishing.com

For customer service and orders:
Toll-Free 1-888-313-2665

Visit us on the internet at http://www.arcadiapublishing.com

*Dedicated to the photographers of Berkshire
County, past and present, and to the Adopt-A-Highway
volunteers who help keep Route 7 beautiful.*

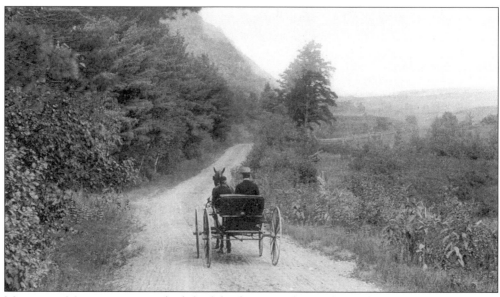

Monument Mountain rises to the left of this lone traveler on the road to Stockbridge in 1892.
(Courtesy of the Sheffield Historical Society.)

CONTENTS

Acknowledgments 6

Introduction 7

Route 7: Then and Now 8

1. Entering Canaan (Connecticut) 9

2. Entering Ashley Falls 19

3. Entering Sheffield 25

4. Entering Great Barrington 37

5. Entering Stockbridge 61

6. Entering Lenox 73

7. Entering Pittsfield 85

8. Entering Lanesborough & New Ashford 105

9. Entering Williamstown 117

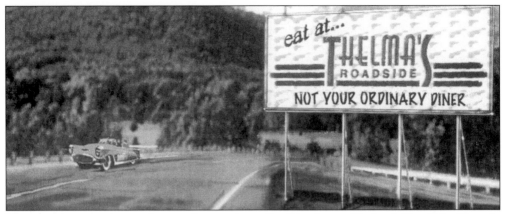

This nostalgic mural once decorated an entire wall of the former Thelma's Roadside Diner in Great Barrington. It was created by Tom Mckay of MSN Architects, New York. (Courtesy of Bruce Firger.)

Acknowledgments

One of my earliest memories is of traveling on Route 7. I was just a kid, sitting in the back seat of my parents' old Buick LeSabre. As I glanced out the car window one evening, I witnessed a strange sight—row after row of cars lined up in a peculiar pilgrimage toward a gigantic white wall. A glowing neon sign explained it all: "Canaan Drive-in Theater." Years later, when I left the Berkshires to attend college in Danbury, Connecticut, I found myself heading south on Route 7. Once again, the road was pointing the way to new adventures.

After college, I returned to Berkshire County via Route 7. Except for two "detours" out of the area, I have lived and worked here ever since. Over the past year, I have had the chance to view Route 7 as few others have—through the eyes of those who came before us. Of course, the pictorial journey that follows is far from complete. The more than 200 images that I managed to squeeze onto these pages offer but a glimpse of the whole picture.

I am most grateful to the talented photographers, past and present, whose wonderful works grace these pages. I am also thankful for the many friends, neighbors, family members, organizations, and businesses that shared photographs with me. Their names are included with the photographs throughout this book.

Special thanks to Fred Hall, James Miller, Donald Victor, Barbara Allen, Clemens Kalischer, Nancy and Art Marasco, David Gilmore, Judy Rupinski, Virginia Larkin, Mick Callahan, Grace McMahon, Lani Sternerup, Irene Tague, Ed LeFebvre, Nancy Burstein, and Phyllis Oleson.

Many others also offered help, suggestions, memories, and wisdom: Debbie Abraham, Ned Allen, Dean Amidon, Gregg Anderson of the Drive-in Theatre Fan Club, Shawn Baker Signs, Dawn Barbieri and the Ramsdell Library staff, William Baumgartner, Brodie Mountain Ski Resort, Tony Carlotto and Steve Carlotta of the Snap Shop, Elizabeth Chapin, Bob Consolini, Bernard Drew, Marlene Drew and the Mason Library staff, Susan Eisley, Mike Fitzpatrick, Sherry Gaherty, Irma Giegold, Amy Giroux of ADG Graphic Design, Jane and Bernie Green, Martha Greene of the Bushnell-Sage Library, Dean Hammond, Lee Harvey, Rita Hoar, Verna Houff, David Klausmeyer, Kwik Print, Sandra Larkin, Audrey Leveille, Doris Longaven of the Hunt Library, Elizabeth Marzuoli of the Massachusetts State Archives, Don and Priscilla Moulthrop, Kathleen Oppermann, James Parrish, Norm Pelletier, Julia Peters, Planet Color, Mary Reilly, Berkshire Athenaeum Local History Room, Robert Tolomeo of the Connecticut State Police Canaan Barracks, Burt and Jerri Veronesi, Eric Wilska of Bookloft, Roberta Wheeler, and Daniel Zilka of the American Diner Museum.

INTRODUCTION

In the beginning, Route 7 was an intermittent footpath through a howling wilderness. The trail was first trampled down centuries ago by Native Americans engaged in hunting and trading. During the summer months, nomadic tribes followed portions of this path south to the seashore in search of fish and clams. These Mahican Indians were part of the Algonquin nation.

Evidence indicates that there was a substantial Native American population in the southern Berkshires for thousands of years before the arrival of Europeans. By the time the Dutch and English arrived in 1730, the Mahicans were living in two small villages, one at Stockbridge and one in Sheffield. According to tradition, the Mahicans had been in steady decline long before the establishment of Stockbridge. The tribe may have been reduced in size by war with other tribes and was eventually driven from the Hudson Valley, back to its ancestral hunting grounds along the Housatonic River. Since the 1700s, the road we now call Route 7 has meandered more than the mighty Housatonic, which it often parallels. Over the years, major portions of Route 7 have been rerouted, raised, lowered, straightened, widened, abandoned, and adjusted.

Stretching 55 miles from Canaan, Connecticut, to Williamstown, Massachusetts, Berkshire Route 7 has long been an icon of beauty, vitality, entertainment, change, controversy, and even humor. It is a road rich in history.

The first practical alternating current transformer was used to light up a string of glass bulbs in shops along Route 7. Legendary civil rights pioneer W.E.B. Du Bois was born just a block from Route 7. While still a teenager, Du Bois worked as a timekeeper for the construction company that built Searles Castle, located along Route 7. On September 2, 1902, Pres. Theodore Roosevelt was injured in a trolley accident on a busy stretch of the road in Pittsfield. Humorist Josh Billings was born on a hill overlooking the highway and is buried in a Lanesborough cemetery bordering Route 7. Since 1976, the bike-racing portion of the Great Josh Billings Runaground triathlon has taken place on Route 7.

Just a stone's throw from Route 7, Phoebe Jordan became the first woman in the United States to legally drop her ballot into the voting box during a presidential election. During Prohibition, rumrunners smuggled illegal booze from Canada to Connecticut along Route 7. Norman Rockwell's studio once stood proudly alongside a stretch of the road in Stockbridge. Williams College, one of the first schools of higher learning in America, was founded near Route 7. The list goes on and on.

As Route 7 redefined itself from a dusty dirt road to an asphalt avenue, postcard makers and photographers captured the changes along the way. Some of the vintage images in this volume date back as far as the 1870s, but the collection also includes many superb photographs from the last 50 years. Turn the page and take a stroll along old Route 7. Keep an eye out for forgotten quarries, old drive-in theaters, trolley car diners, full-service gas stations, and roadside tourist stops such as the Red Bat Cave in New Ashford. Enjoy vintage views of welcoming woodlands, majestic mountains, beautiful waterways, towering elms, and family farms. These images offer a rare glimpse through the window of our past.

Faced with ever increasing economic pressures and traffic, Route 7 has become an occasional battleground for the forces of growth against the forces of preservation. Most everyone in the Berkshires has an interest in Route 7. The scenic towns and villages nestled along this historic highway have many common bonds. By traveling along Route 7, then and now, the connections between past and present will become more apparent. By understanding where we have been, we will have a better idea of where we are and where we are headed.

Route 7: Then and Now

Prior to 1922, the road we now call Route 7 was often referred to as the New York-Berkshire-Burlington Way. Blue bands painted on telephone poles marked the route. In the early 1920s, a group of northeastern highway commissioners, hotel associations, and automobile clubs drafted a highway numbering system. When it was implemented in New England and eastern New York, the highway became known as New England Interstate Highway 4. By 1926, however, the federal government had inaugurated its own nationwide numbering system for state highways. That year, drivers found themselves on newly named U.S. Route 7.

In Canaan, Connecticut, Route 7 originally veered southwest, following today's Route 41 through Sharon, Connecticut, to the New York state line. Until it was rerouted to Norwalk, Connecticut, c. 1930, U.S. Route 7 continued along New York Route 22 toward New York City. Prior to 1930, the main road from Canaan to New Milford, Connecticut, was known as Route 134 or the Schaghticoke Trail.

Heading north into Massachusetts, the path of the original north-south road has changed considerably over the past 200 years. Ancient portions of the road saw dramatic changes in the 1800s. The mid-20th century saw the village of Ashley Falls completely bypassed by new Route 7, as was the town of Lenox. Older and newer portions of the original road are now known by many names. A partial list follows:

Canaan: South Canaan Road, High Street, Elm Street, Routes 7 and 44, Main Street, Railroad Street, and Ashley Falls Road.

Ashley Falls: Route 7A, Old Route 7, Main Street, and Ashley Falls Road.

Sheffield: South Main Street, Main Street, and Sheffield Plain. (Until the 1800s, portions of South Egremont Road, West Sheffield Road, East Sheffield Road, and Boardman Street also served as main roads north of town.)

Great Barrington: Sheffield Road, South Main Street, Main Street, State Road, Pixley Road, Old Stockbridge Road, and Stockbridge Road. (Until the 1800s, portions of Lover's Lane, Monument Valley Road, and Alcott Street may have served as a main road north of town by skirting Konkapot Swamp on the east side and connecting with Ice Glen Road.)

Stockbridge: Clark Road, Goodrich Street, South Street, Main Street, and East Street. (Until the 1800s, portions of Ice Glen Road may have served as a main road south of town by skirting the east side of Konkapot Swamp. Portions of East Street near the Kampoosa Bog were probably east of the current highway.)

Lenox: Old Stockbridge Road, Kemble Street, Main Street, Route 7A, Veterans Memorial Drive, Lenox-Pittsfield Road, and Routes 7 and 20. (Until the 1800s, the main road through downtown Lenox wandered east and west of the present Main Street.)

Pittsfield: Routes 7 and 20, South Street, North Street, First Street, Wahconah Street, and Upper North Street.

Lanesborough: South Main Street, Main Street, Pittsfield-Williamstown Road, Old Williamstown Road, and Old Route 7. (Until the mid-1800s, portions of the main road north of town were considerably east of the present highway.)

New Ashford: Old Route 7, Mallory Road, New Ashford Road, Pittsfield-Williamstown Road, and Old Williamstown Road. (Until the mid-1800s, portions of the main road wandered east and west of the current highway.)

Williamstown: New Ashford Road, Cold Spring Road, Glen Street, North Street, Simonds Road, and Pownal Road. (Until the 1920s, Green River Road was considered the main road from South Williamstown to Williamstown.)

One

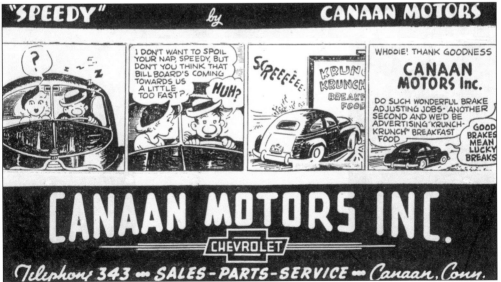

Cartoons featuring the highway high jinks of "Speedy" appeared in the *Connecticut Western News* for many years. (Courtesy of the Hunt Library, Falls Village, Connecticut.)

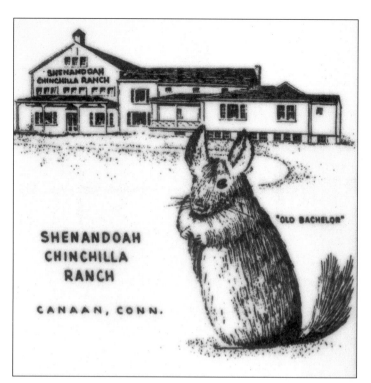

The virile chinchilla on this souvenir tile cavorted in his Route 7 "Playboy mansion," the Shenandoah Chinchilla Ranch. He wore himself out, however, long before it became politically incorrect to wear fur. Most of the rodents he fathered also retired by the late 1950s, and today this facility serves as a health clinic. (Author's collection.)

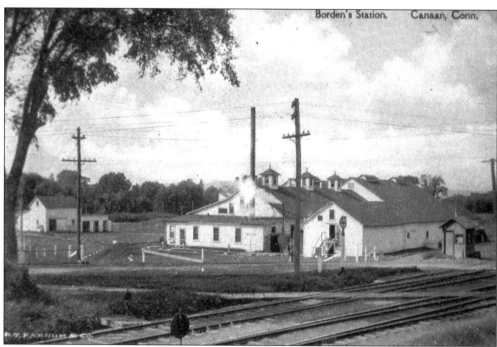

A large Borden's milk processing plant stood on the left-hand side of Routes 7 and 44 from 1901 until the mid-1950s. Apparently the owners milked the operation for all it was worth and then left. A town park and several businesses occupy this site today. (Courtesy of Fred Hall.)

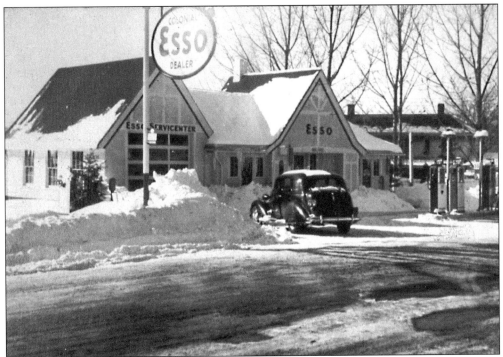

This classic Esso station near downtown Canaan kept motorists moving for many years. The building is now home to the Curtis Insurance Company. (Courtesy of Fred Hall.)

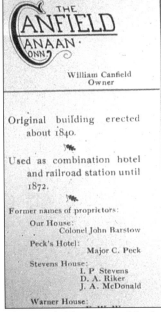

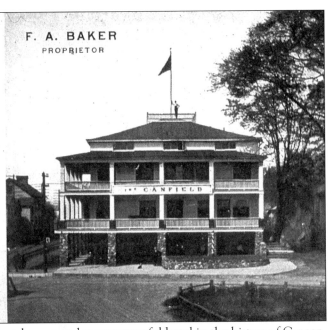

The Canfield was arguably the best-known and most successful hotel in the history of Canaan. The original building was built c. 1840. Also known as Peck's Hotel, the handsome structure served double duty as a train and trolley station for many years. It was torn down several decades ago, and Canaan Pharmacy (now Brooks) was built on the site. (Courtesy of Fred Hall.)

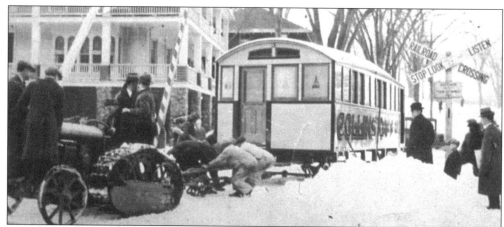

It looks like these men were so hungry that they decided to take the entire diner with them. Actually, this 1924 scene shows the old Collin's Diner being towed to its new home west of the railroad tracks. (Courtesy of Fred Hall.)

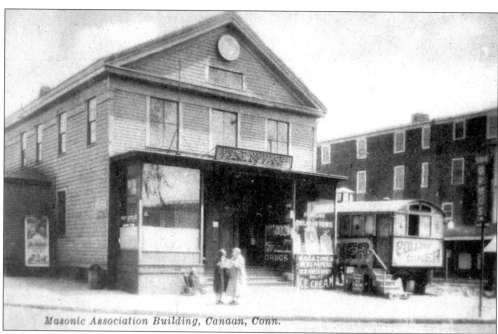

Masonic Association Building, Canaan, Conn.

Collin's Diner was set in place next to the Masonic Association Building (now Bob's Clothing and Shoe Store). It was a logical location because those Canaan Masons were a hungry bunch. In 1941, a sleek new diner was purchased from the legendary O'Mahoney Diner Company in New Jersey. It was put in place opposite the train station, where it remains as popular as ever. (Courtesy Fred Hall.)

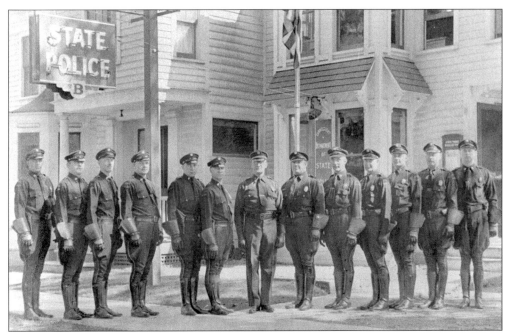

This is a gentle reminder to behave yourself while driving through Canaan. In the late 1920s, Connecticut State Police Barracks B stood on Main Street near the town library. The sign in the upper left still hangs in front of the current barracks building, which was built near the state line in 1941. (Courtesy of Dean Hammond.)

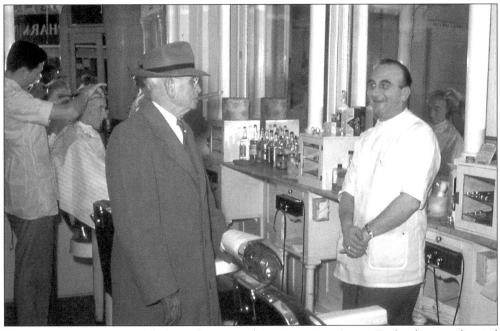

This barbershop quartet really knew how to make scissors sing. Scott's Barbershop was located in the Canfield Block (west of the railroad tracks) when this 1960s picture was taken. Shown pointing a cigar at barber Paul Amenta is retired owner Henry Scott. The two men in the back were too busy to give their names. (Courtesy of Fred Hall.)

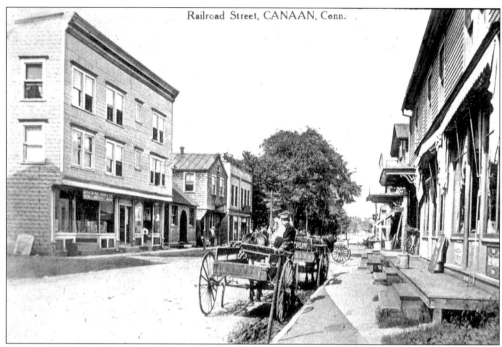

Welcome to downtown Canaan *c.* 1910. Perhaps everyone was camera-shy the day this picture was taken. (Courtesy of Fred Hall.)

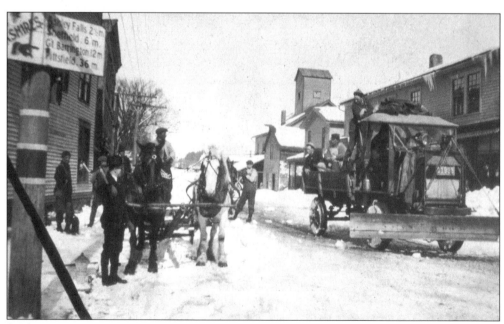

By the 1920s, Canaan residents had figured out how to keep the downtown area clear of snow. Note the interesting directional sign in the upper left. (Courtesy of Fred Hall.)

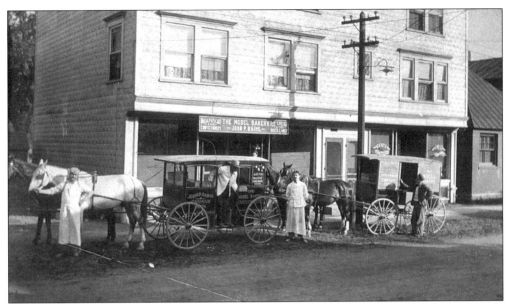

If you hold this page up close, you might be able to smell the freshly baked goodies at Model Bakery. With two delivery wagons lined up, Model's business (and bread) must have been on the rise. This building still stands on the west side of Railroad Street. (Courtesy of Fred Hall.)

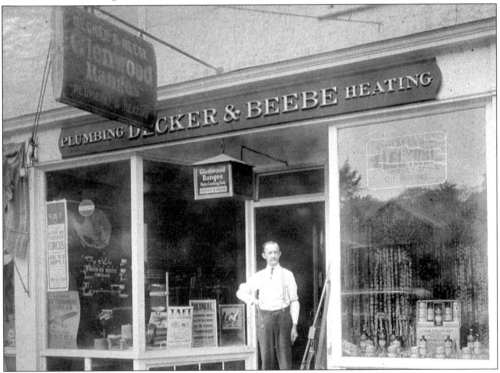

The Decker & Beebe Company is one of the oldest businesses still operating in Canaan. Without them, just imagine how many pipes would be clogged and furnaces frozen. When this early-1900s picture was taken, the firm's pipe-patching headquarters was downtown in what is now the Mahaiwe Jewelry Store. (Courtesy of Fred Hall.)

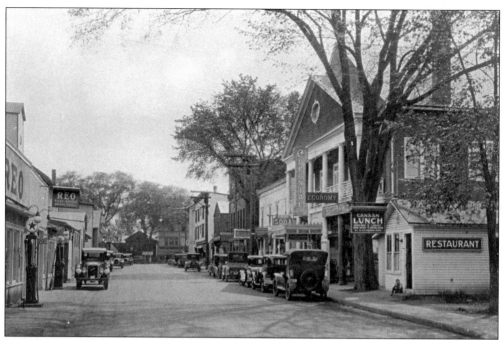

Wanted: the perfect downtown *c.* 1926. It must have an old restaurant and movie theater on the right with a vintage REO garage on the left. Classic cars on the street and healthy elm trees are also desirable. A northwestern Connecticut location is preferred. (Author's collection.)

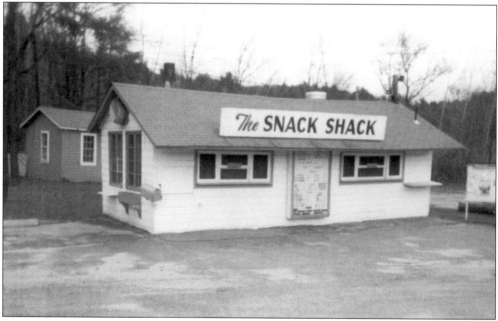

Legend has it that Route 7 was built so that stagecoaches could stop at the Snack Shack. This may be an exaggeration, but the longstanding eatery (earlier known as the Red Apple) has been welcoming hungry travelers for a good portion of the 20th century and beyond. In the mid-1990s, the modest building shown here was replaced by a larger log structure. A miniature golf course and a batting cage were also added. (Courtesy of Missy Ohler.)

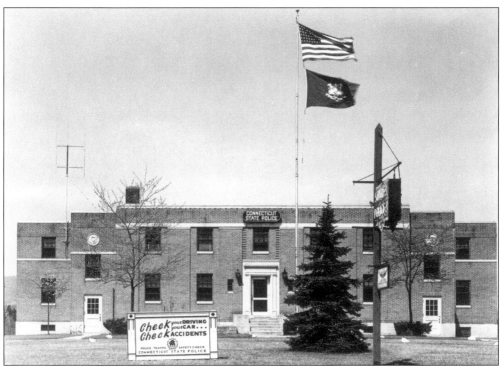

Since 1941, Connecticut State Police Barracks B has been a familiar site along Route 7, near the Massachusetts border. This photograph was taken in 1951. (Courtesy of Dean Hammond.)

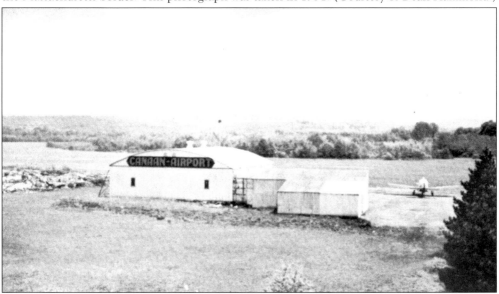

The Canaan Airport was no fly-by-night operation. It served the tri-state area faithfully for many years. The welcoming airfield was wedged between the Massachusetts border and old Route 7. After the airport fell on hard times, the Canaan Drive-in Theater took over a portion of the property in 1950. Several years later, an all new Route 7 was laid directly behind the hanger shown in this 1940s view. The hanger still stands between old and new Route 7, but is hidden by the forest that has grown up around it. (Author's collection.)

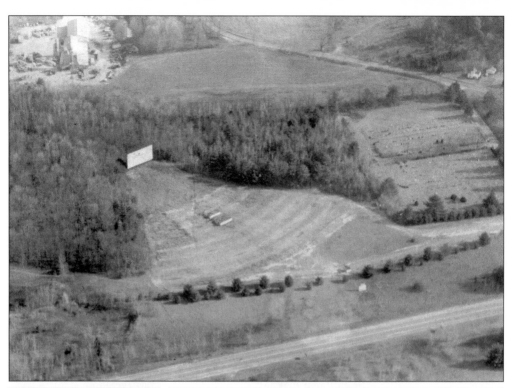

When the Canaan Drive-in Theater first opened on Saturday, May 27, 1950, it was a proud moment for owner Louis Consolini. The screen was reportedly the largest in Connecticut, measuring 60 by 64 feet. The parking lot was designed to accommodate 500 cars, and a well-stocked concession stand offered ample refreshment. The operation was a big hit and enjoyed great success for a number of years. Like most drive-ins, however, the Canaan theater fell on hard times during the 1970s, and the giant screen was eventually torn down. Today, the Tallon Lumber Company occupies the site. (Courtesy of Tallon Lumber Company and the author's collection.)

Two

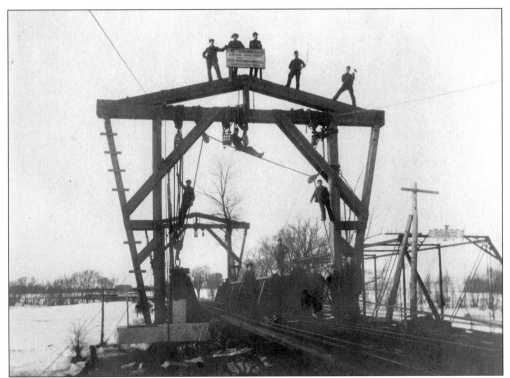

Just north of Ashley Falls, acrobatic builders span the Housatonic River with a new railroad bridge *c.* 1900. The sign at the top reads, "Lewis F. Shoemaker & Co., Schuylkill Bridge Works, Manufacturers of Steel Buildings and Bridges, Harrison Bldg, Phila." The bridge on the right supported the highway. By 1911, a third bridge had been added for trolley cars. (Courtesy of the Sheffield Historical Society, Mark Dewey Research Center.)

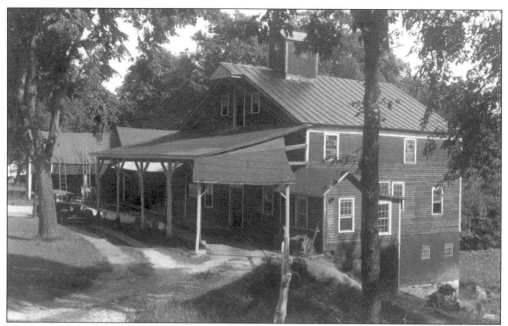

Ashley Falls is a village within the township of Sheffield. For many years, the Old Red Grist Mill was one of the most picturesque structures in the village. It was built in the 1830s and served area farmers for generations. Reopened as a bakery in the 1930s, the mill continued to grind whole-wheat flour for shipment all over the country. When Ashley Falls was bypassed by the new Route 7 in 1960, business slowed and the mill eventually fell into disrepair. Damaged by fire in 1969, it still stands today, partially restored but unused. (Author's collection.)

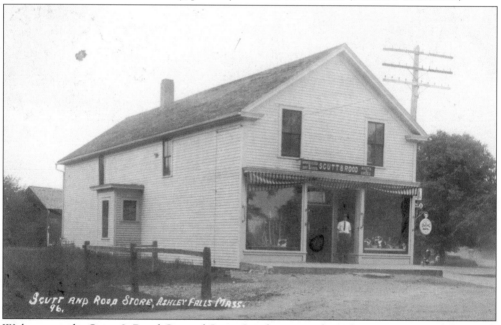

Welcome to the Scutt & Rood General Store. Inside is everything from groceries and dry goods to shoes and watches. This photograph was taken in 1914, when the highway was still a dirt road. The building is now home to the Ashley Falls Post Office. (Author's collection.)

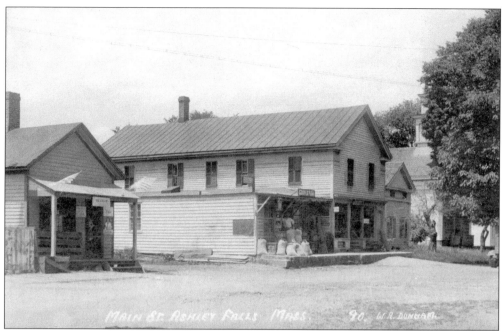

Downtown Ashley Falls supported numerous retail businesses in the early 1900s. The smaller store on the left advertised ice cream and other goodies. Dunham's Store on the right sold hardware, farm equipment, and groceries. For the past several decades, Maplewood Fabrics has been located here. (Dunham photograph from the author's collection.)

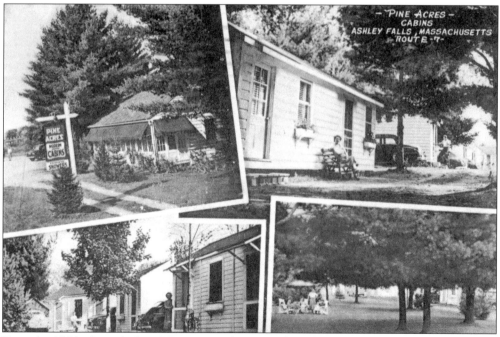

From the 1920s through the 1960s, scores of tourist cabins dotted the entire stretch of Route 7. Pine Acres and the Ledges were two of several in Ashley Falls. (Author's collection.)

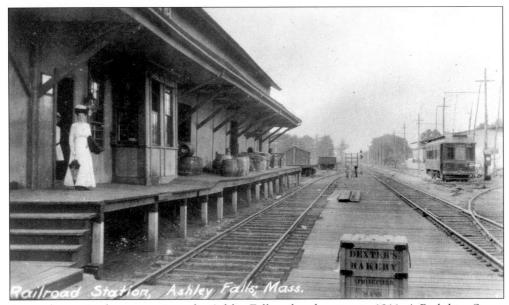

A traveler awaits the next train at the Ashley Falls railroad station in 1911. A Berkshire Street Railway trolley car is parked to the right during construction of the trolley line south to Canaan. Dexter's Bakery in Springfield, Massachusetts, gets free advertising on the crate in the foreground. (Author's collection.)

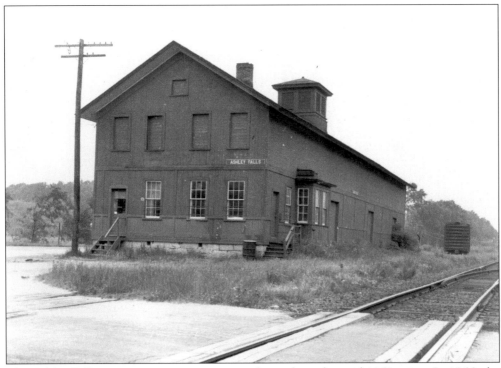

The Ashley Falls train station is overgrown with weeds in this mid-1950s view. In 1966, the depot burned to the ground, and today a private home occupies the site. (Charles Gunn photograph from the author's collection.)

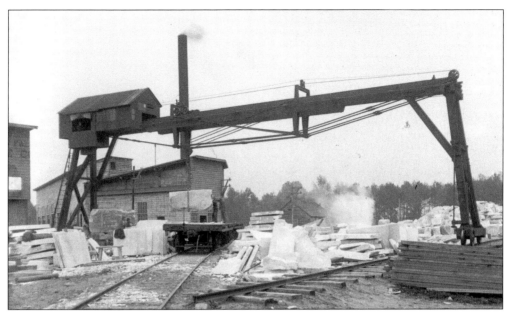

The Ashley Falls Marble Quarry was a rock-solid employer in Ashley Falls from 1876 until a 1916 fire burned the entire plant to the ground. In earlier years, the business was flushed with success after it contracted to supply marble bases for bathroom toilets. Thousands of marble tombstones were also shipped to Arlington National Cemetery. The huge derrick shown here rolled back and forth over the quarry pit on parallel railroad tracks. Driving through Ashley Falls today, it is hard to imagine such a big operation was only a stone's throw from downtown. (Courtesy of the Sheffield Historical Society.)

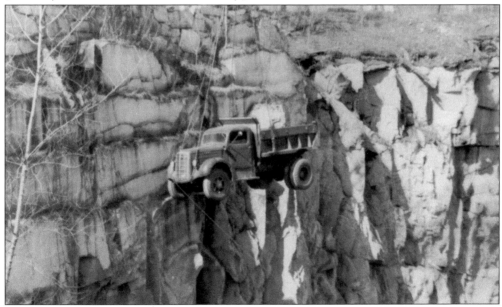

Is this an Ashley Falls amusement park ride? No, this 1946 view shows a truck being lowered into the Ashley Falls Quarry. Scrap marble and crushed stone continued to be mined periodically until the late 1940s. Then the quarry pit was allowed to fill with water and is now a private pond. (Courtesy of Grace Brown.)

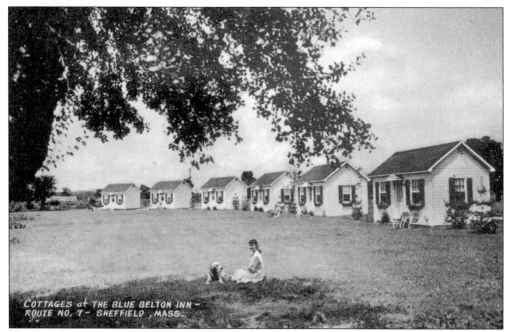

COTTAGES at THE BLUE BELTON INN — ROUTE NO. 7 — SHEFFIELD , MASS.

The Blue Belton Inn was located near the intersection of Route 7 and 7A, a few miles north of Ashley Falls. The resort featured a sizable inn, separate cottages, a private golf course, a swimming pool, tennis courts, and a restaurant. The main building became a private school for a few years, and later the JW Steak House. Apartments now occupy the site. (Author's collection.)

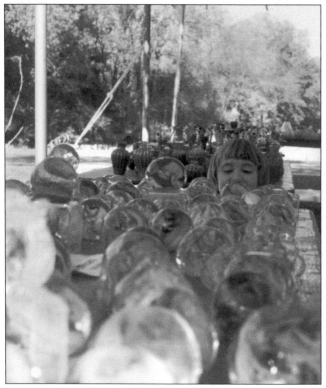

A young admirer is intrigued by glistening glass globes made by Fellerman & Raabe Glassworks. Located south of Sheffield on Route 7, the studio has periodic roadside sales of its glass masterpieces. (Author's collection.)

24

Three

ENTERING

SHEFFIELD

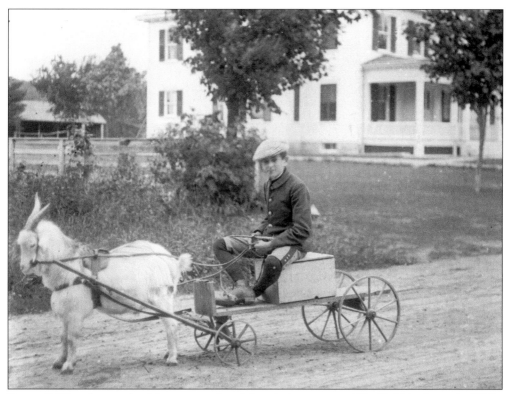

Young Ed Boardman takes his goat cart for a leisurely jaunt around Sheffield in the early 1900s. Lack of horsepower never made his billy goat gruff. (Courtesy of the Sheffield Historical Society, Mark Dewey Research Center.)

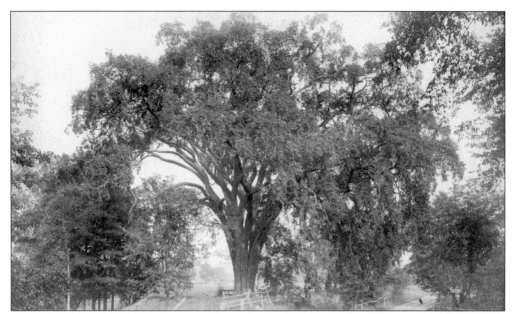

The elegant Sheffield Elm lived long and prospered for about 400 years. This c. 1890 photograph shows the ancient tree in all its glory with tiny Route 7 as a dirt road on the right. By 1926, the elm was in poor health and was taken down. A bronze plaque now marks the site. The few surviving elms along Route 7 are now being monitored, treated, and protected by Elm Watch, an organization headed by Tom Zetterstrom of Canaan, Connecticut. (Kendall photograph from the author's collection.)

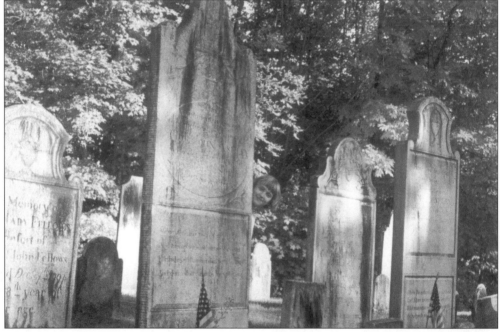

Tall tombstones encourage games of hide-and-seek in this ancient Sheffield cemetery. Buried here are the legendary Col. John Ashley and his wife, Hannah, prominent founding residents of Berkshire County. (Author's collection.)

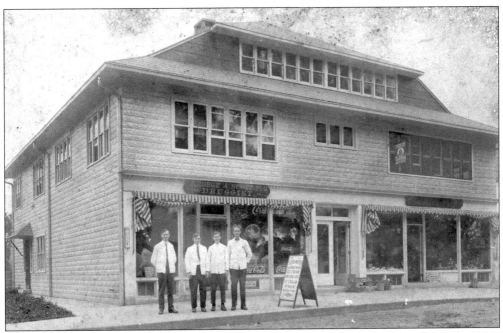

The friendly employees of George Scott's Drug Store welcome customers in this early-1900s view. Known as the Bartholomew Block, this building now houses Sheffield Pizza and Sheffield Market. (Courtesy of the Sheffield Historical Society.)

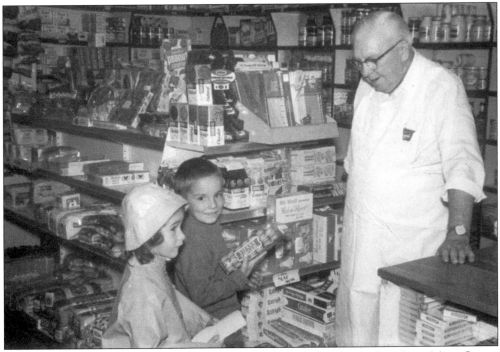

Francis Kersey advises two of his favorite customers at "the Stone Store" on Main Street. (Courtesy of the Sheffield Historical Society.)

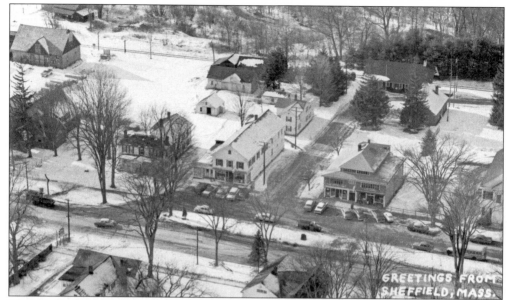

This bird's-eye view reveals a slippery downtown Sheffield. Majestic elms once lined this stretch of road until the deadly Dutch elm disease arrived in the 1930s. A few hearty survivors still stood when this picture was taken in the 1950s. (Author's collection.)

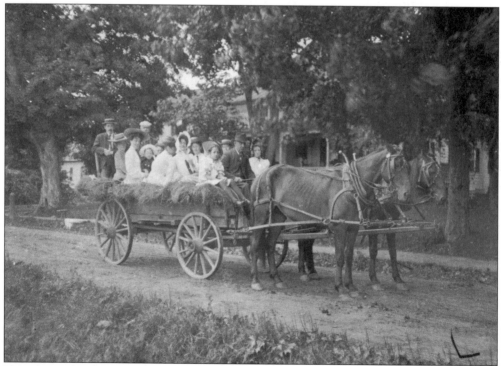

If you have a hankering for a hayride, hitch up a wagon and come to Sheffield. (Courtesy of the Sheffield Historical Society.)

28

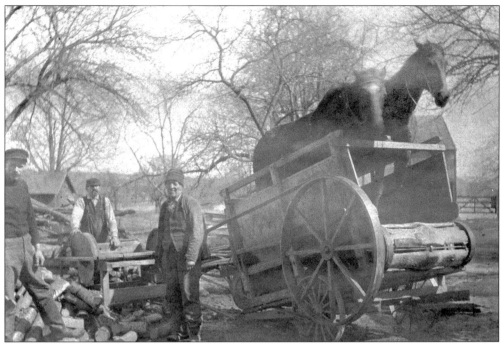

These clever Sheffield woodcutters never had it so good. Their 2-horsepower "engine" is on the cutting edge of 1890s technology. (Courtesy of the Sheffield Historical Society.)

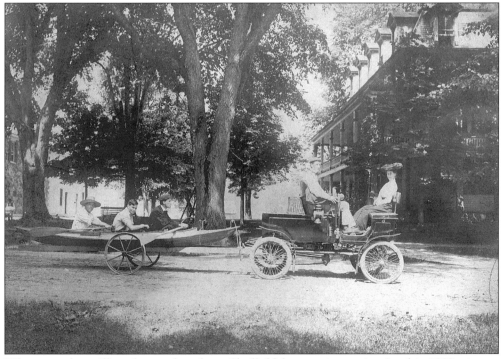

Whenever the millpond runs dry, these Sheffield boaters improvise. In this 1903 view, a Locomobile with face-to-face seating tows a light launch past the old Taghanick Inn. Gulotta's service station now stands on this site. (Courtesy of the Bushell-Sage Library, Sheffield.)

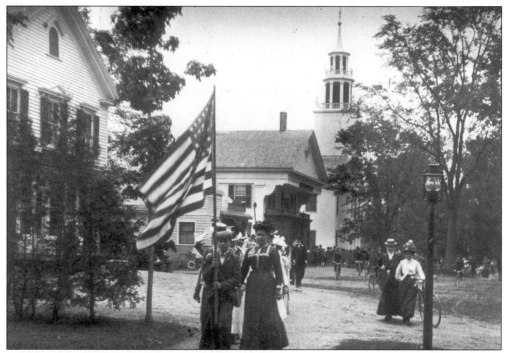

A young boy leads a procession of women in this early-1900s parade. The Congregational church steeple can be seen in the background. (Curtesy of the Sheffield Historical Society.)

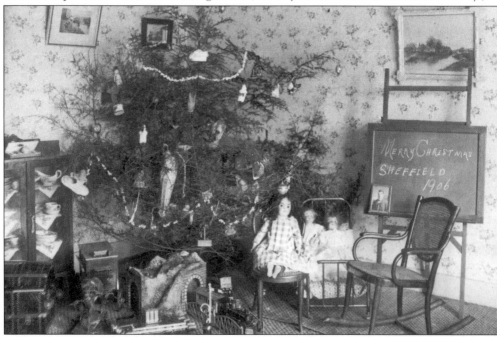

A cheerful chalkboard spells out season's greetings for Sheffield. The festive evergreen is surrounded by toys for good Sheffield girls and boys. This photograph was taken inside the Centuryhurst estate on Main Street. (Carrie Smith Lorraine photograph courtesy of the Sheffield Historical Society.)

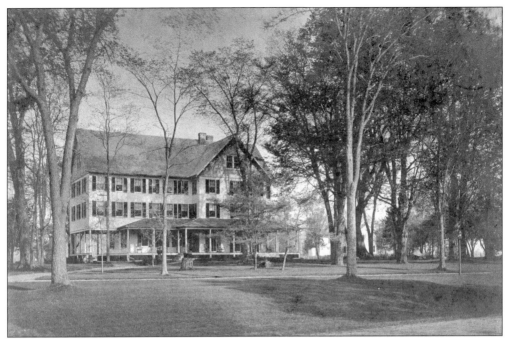

For many years, the Elmhurst Hotel stood on the north end of downtown Sheffield, across the street from Macy's Garage (recently renovated). The stately structure also housed a private school in its later years. It eventually fell into disrepair and was torn down in the 1960s to make room for a parking lot. (Author's collection.)

Dunham's "auto plant" offered repair service for steam, gasoline, and electric automobiles. It was located across the street from the Elmhurst Hotel. In 1921, Macy's Garage was built on the site. (Courtesy of the Sheffield Historical Society.)

Crowds gather along concrete-paved Route 7 during the 1946 Memorial Day parade. Francis Kersey is the grand marshall, followed by Raymond Peters, Gilbert Wright, Frank Percy, and Ed Arcutt. (Courtesy of the Sheffield Historical Society.)

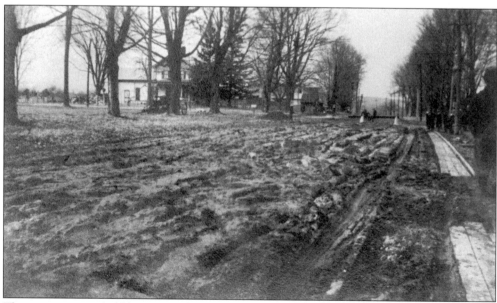

The next time you feel like griping about a pothole, remember this *c.* 1900 scene of Route 7 near Cook Road. Note the plank sidewalk on the right. (Courtesy of the Sheffield Historical Society.)

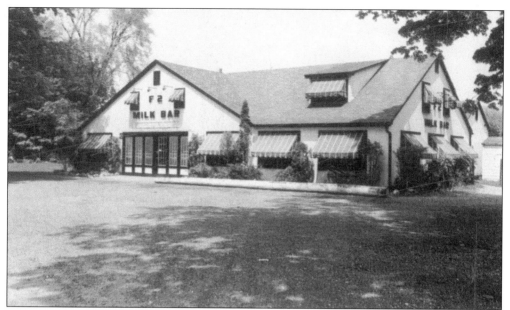

Famous for its peculiar name as well as its good food, the F-2 Milk Bar was one of Sheffield's most popular restaurants. It began as a small dairy bar in 1937 and was expanded several times over the years. According to local legend, owner Frank Zollner used his initials, F.Z., to name the business, but the Z on the building looked more like the number 2, and the name stuck. Later known as Caesar's Shed, the local eatery is now Limey's Restaurant. (Author's collection.)

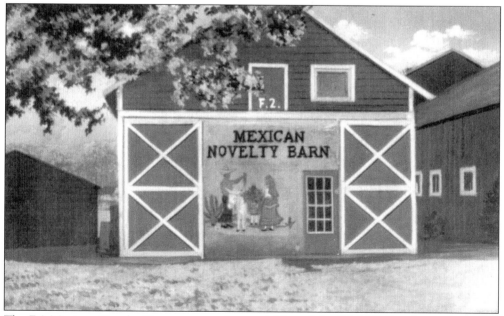

The F-2 Mexican Novelty Barn was a southern neighbor of the F-2 Milk Bar. Located near the Housatonic River (Sheffield's version of the Rio Grande), it was an ideal location for a siesta or a souvenir. As a multicultural shop, it also offered items made in Japan. (Courtesy of Virginia Larkin.)

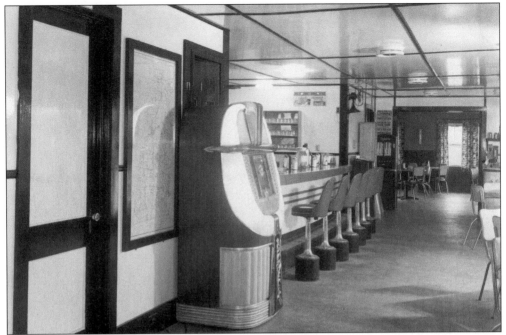

Tasty food and this classic jukebox kept customers singing at the F-2 Milk Bar. A Mahaiwe Theater poster on the back wall advertises the movies *Fighter Attack* and *Walking My Baby Back Home*, dating this photograph to 1953. (Tassone photograph courtesy of the Great Barrington Historical Society.)

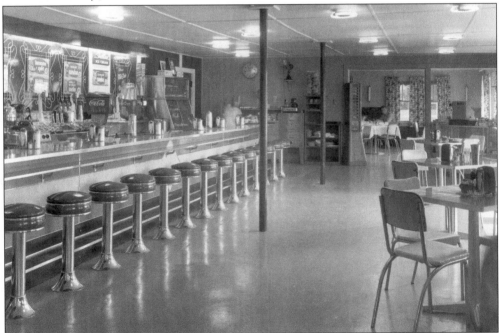

This similar view of the F-2 Milk Bar was taken after the interior was remodeled. The date is unknown, but a counter sign advertises a banana split sundae for 40¢. (Tassone photograph courtesy of the Great Barrington Historical Society.)

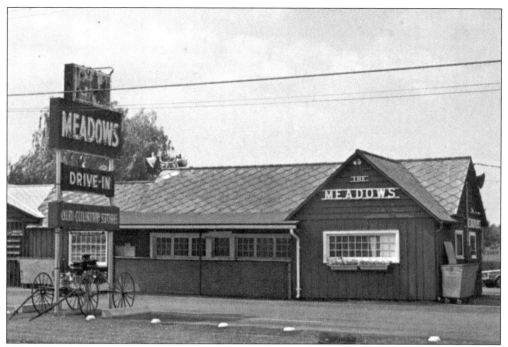

A portion of this building originally stood farther north on Route 7. In the 1950s, Mary and Frank Knoll moved it to this location and opened the Meadows, the first drive-in seafood restaurant in the Berkshires. Many longtime residents still rave about the amazing fried clams served there. Mary Knoll also operated the Knoll's Fine China and Gift Shop, now home of Susan Silver Antiques. The Meadows is now the Bradford Auction Gallery. (Author's collection.)

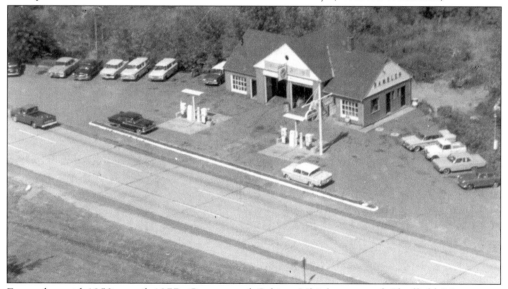

From the mid-1950s until 1977, George and Sabina Ulrich operated Sheffield Motors, an American Motors Rambler dealership on Route 7. Since that time, the building has served as a real estate office and a consignment shop. The building recently underwent extensive remodeling and now houses offices for a nonprofit organization. (DeWolf photograph courtesy of Sabina Ulrich.)

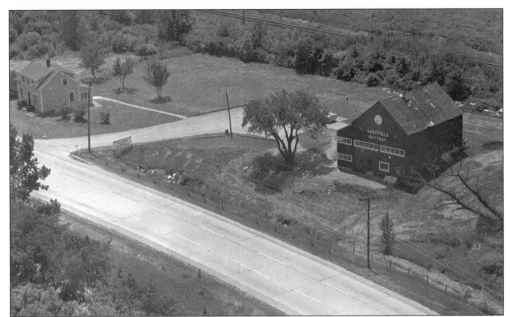

Sheffield Pottery is one of the oldest surviving roadside attractions in the Berkshires. The Cowen family began the business in 1945 and has successfully molded it into a thriving wholesale and retail operation. When this aerial view was taken in the early 1950s, a triple-lane Route 7 was paved with concrete. After numerous auto accidents, this three-lane design was scrapped, only to be resurrected years later on Route 7 north of Great Barrington. (Courtesy of John Cowen.)

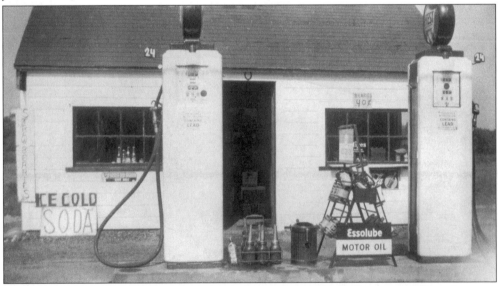

The Mackoul family opened the Midway gas station in 1948. Located midway between Sheffield and Great Barrington, it was originally an Esso station and later sold Shell gasoline. A celebrity or two has stopped at this station over the years, including Queen Wilhelmina of the Netherlands while on her way to Tanglewood. Frank and Mary Mackoul later opened Marty's Luncheonette next door. The site is now home to Madison Architectural Antiques. (Courtesy of Mary and Howard Hassan.)

Four

ENTERING
GT BARRINGTON

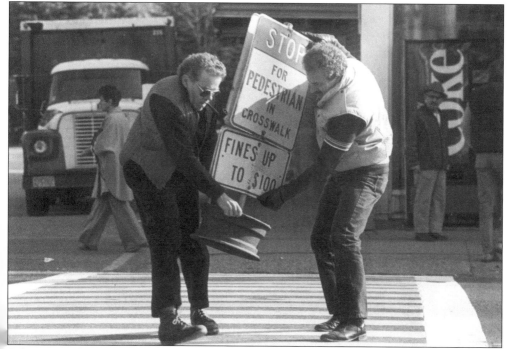

Selectmen John Mooney and Edward Morehouse replace a crosswalk sign on Main Street in 1984. Downtown motorists occasionally overlook the state law protecting pedestrians. (Don Victor photograph.)

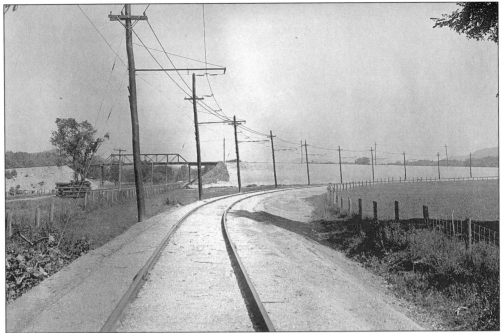

In 1910, the Berkshire Street Railway Company began construction on a trolley line extension from Great Barrington to Canaan, Connecticut. This view looking north shows the trolley line as it approaches a new raised track extension also being built to South Egremont. After only nine years of use, this portion of the trolley line was abandoned in 1919. Most of the raised roadbed shown here was hauled away for use as fill elsewhere. The cement pylons supporting the bridge can still be seen standing in a field behind Seward's Tire Company on South Main Street. (Author's collection.)

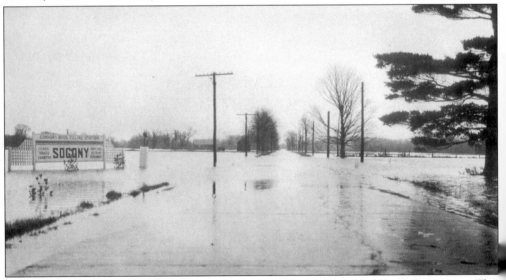

Highway flooding was once a common occurrence on Route 7 south of Great Barrington. This 1927 view shows the Connors Brothers Filling Station sign surrounded by high waters. The old gas station is now a snack bar in front of Bogie's Steak House. (Courtesy of the Berkshire County Historical Society.)

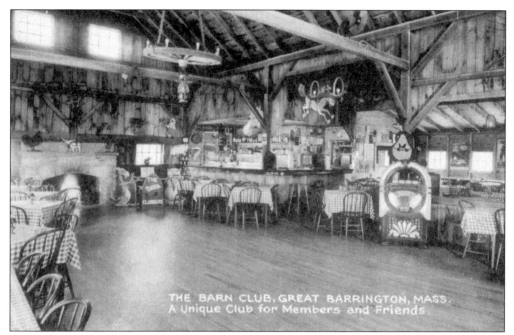

One of the most popular resorts along Route 7 was Abe Hammer's Barn Club. Opened in 1936, the resort offered food, drink, dancing, swimming, and golf. This interior view was taken in the 1940s. In the early 1990s, the barn was extensively remodeled and is now Bogie's Steak House. (Author's collection.)

This hexagonal structure was the clubhouse for the first golf course in Great Barrington. It was built in 1896 on Maple Avenue, where a modest course consisted of six tomato cans in a cow pasture. Unfortunately, the cows would block players' shots, and numerous cow pies gave new meaning to the term "hitting into the rough." After land was acquired between Route 7 and the Housatonic River, the clubhouse was moved to the site shown here. Known as Wyantenuck, the nine-hole course also proved to be too confining. In 1913, extensive acreage was purchased on West Sheffield Road, where Wyantenuck remains today. (Lane Brothers photograph from the author's collection.)

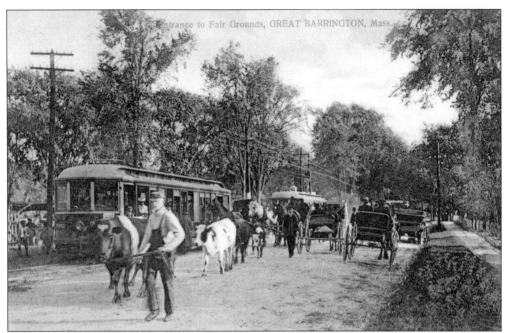

This is probably one of the first traffic jams in Great Barrington. The peculiar back-up involves two prize cows leading a procession of trolleys, automobiles, horses, and pedestrians. Excitement is in the air as folks hurry to the key social event of the year—the Housatonic Agricultural Exhibition, better known as the Great Barrington Fair. (Author's collection.)

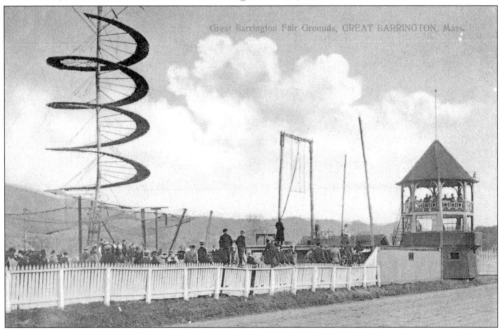

Many consider the Berkshires to be heaven on earth and, if so, this must be the original stairway to heaven. Actually, this apparatus was part of a daredevil act that was featured at the Great Barrington Fair *c.* 1910. The tower on the right served as the judges' stand for horse racing events. (Author's collection.)

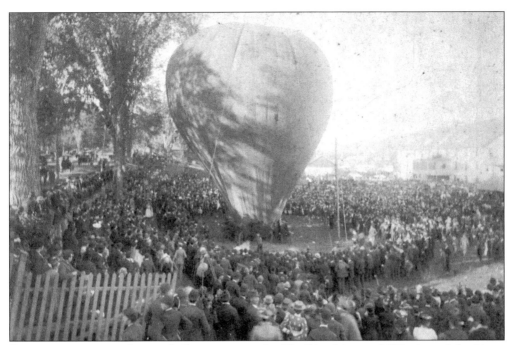

Spirits soar as a giant hot-air balloon prepares for liftoff in this rare 1892 view of the Great Barrington Fair. Judging by the large crowd, this airborne act was a big hit. (Lanes Brothers photograph courtesy of Marc Membrino.)

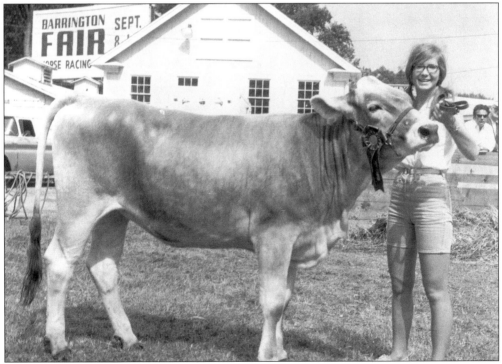

Terry Cruikshank and her award-winning cow pose proudly at a 1960s Great Barrington Fair. (Marie Tassone photograph courtesy of the Great Barrington Historical Society.)

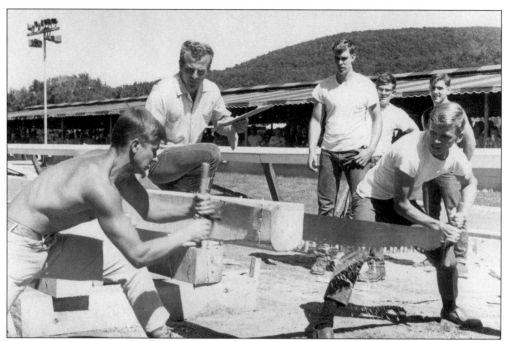

Ready, set, saw! These sturdy lads sharpen their skills during a 1960s log-cutting competition at the fairgrounds. (Marie Tassone photograph courtesy of the Great Barrington Historical Society.)

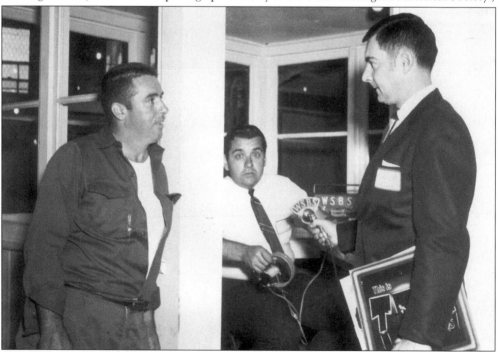

John Tully (left) chats with Jack Ryan in this early-1970s fairgrounds picture. WSBS newsman Tom Jaworski (center) looks like he has seen a few too many horse races. Twenty-five years later, "Tom J." was the first broadcaster at the scene when a devastating tornado ripped apart the fairgrounds. (Marie Tassone photograph courtesy of the Great Barrington Historical Society.)

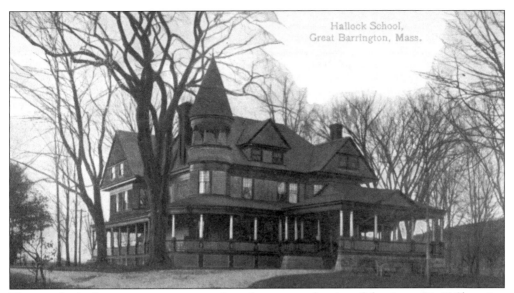

This spooky-looking mansion once stood on the present-day site of the Ames-Big Y Shopping Center. It was built as a summer home by William Tefft, a wealthy wholesaler from New York City. After Tefft's death, the property became a preparatory school known as the Hallock School. In 1947, controversy erupted when the Moorish Science Temple, a black religious sect, purchased the property. In 1963, a Zayre Department Store and Adams Supermarket were built on the site. (Author's collection.)

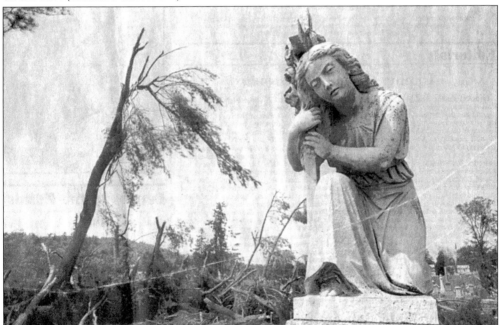

On May 27, 1995, a deadly tornado blasted through Great Barrington, tossing trees and smashing homes. After the twister toppled tombstones in the Mahaiwe Cemetery, it roared across Route 7, leveled the fairgrounds, and continued on its path of destruction. This poignant photograph symbolizes the burden residents faced in the aftermath of the storm. (Craig F. Walker photograph courtesy of the *Berkshire Eagle*.)

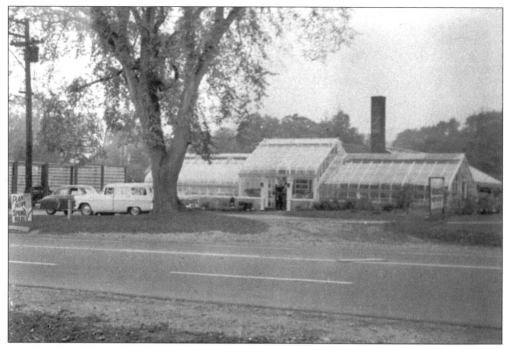

Since 1935, this site on South Main Street has been home to a growing business. It all began when Warren Dolby opened a greenhouse and perennial nursery here. Business really blossomed in 1957 when new owners Don Ward and Matthew Tomich set down roots. When this picture was taken shortly afterward, the place had enough parking for about five cars. Ward's Nursery and Garden Center has grown considerably and is now operated by Don and Lorraine Ward's children, all of whom were born with green thumbs. (Courtesy of Don Ward Jr.)

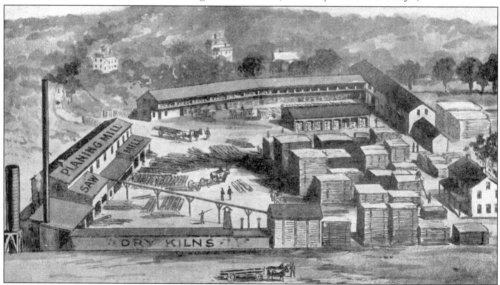

Few realize that the Olympian Meadows Little League field, located just north of the fairgrounds, was once occupied by one of the largest lumbermills in Berkshire County. Here, in the late 1800s, C.R. Brewer operated a sawmill, planing mill, dry kiln, box factory, and lumberyard. Little evidence remains today of Brewer's Mill. (Author's collection.)

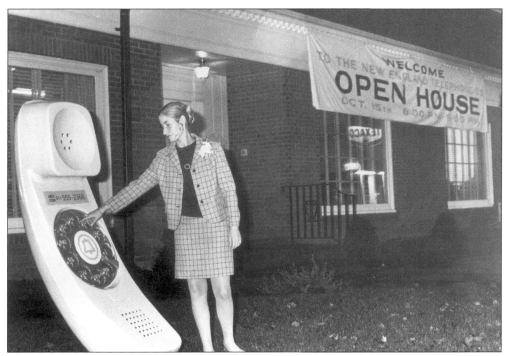

Has Great Barrington enlarged its 911 emergency phone system? No, this photograph was taken at a New England Telephone Company open house in the 1960s. Today this building is home to the Great Barrington Police Department. (Marie Tassone photograph courtesy of the Great Barrington Historical Society.)

The Berkshire Inn stood proudly on Main Street where Bill's Pharmacy and Days Inn are today. Built in 1893, the hotel was considered one of the most impressive structures along Route 7. After a third-floor fire in 1965, the hotel was torn down. Many longtime residents wish that the structure had been saved. (Author's collection.)

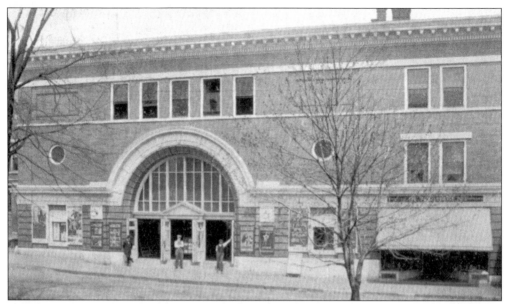

Noted Pittsfield architect Joseph McArthur Vance designed the elegant Mahaiwe Theater as well as Pittsfield's Colonial Theater. Following the Mahaiwe Theater's grand opening in 1905, many famous personalities graced the local stage, including John Philip Sousa, comedian Ed Wynn, and orator DeWolf Hopper (*Casey at the Bat*). The multibulb marquee that now hangs over the entrance was not added until the 1930s. (Author's collection.)

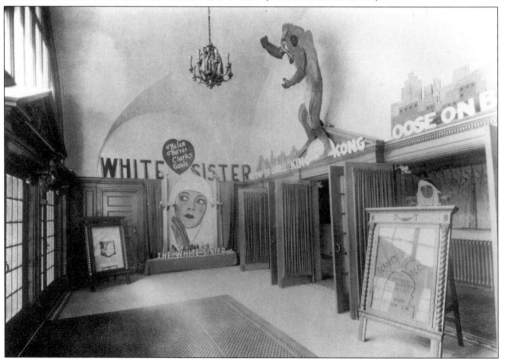

During the 1930s, the Mahaiwe Theater's lobby was well decorated with promotional material. Shown here are eye-catching displays for *White Sister* and *King Kong*. (Courtesy of the Berkshire County Historical Society.)

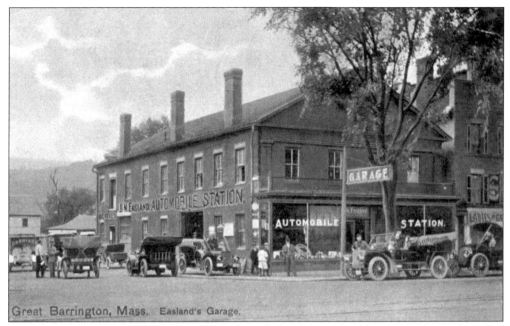

Great Barrington, Mass. Easland's Garage.

The corner of Main and Bridge Streets has changed considerably since 1910, when this photograph was taken. Easland's Automobile Station was a thriving business, but the building was later torn down and replaced with an A & P grocery store. The Pittsfield Cooperative Bank stands on the site today. (Author's collection.)

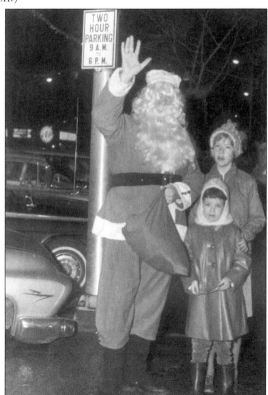

Santa's sleigh may have exceeded its two-hour parking limit, but these kids don't seem worried. (Marie Tassone photograph courtesy of the Great Barrington Historical Society.)

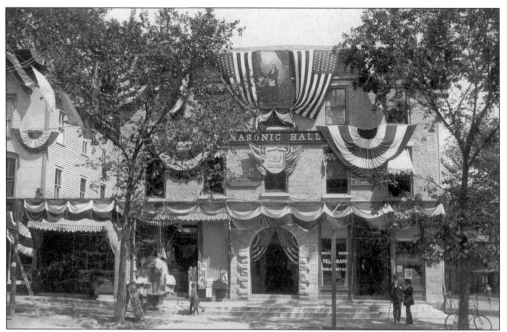

Could this be the grand opening of the Subway sandwich shop? No, it's the right building but the wrong century. In this 1895 view, the meeting hall of the local Masons is decorated with patriotic banners for the lodge's centennial. (Costello photograph courtesy of the Great Barrington Historical Commission.)

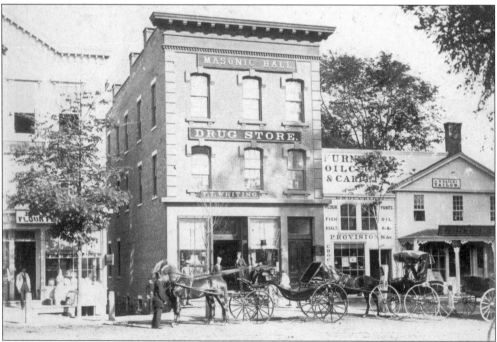

In the late 1800s, this building housed Whiting's Drug Store. But what popular store is located here today? Here's a hint: Kids love the place. Give up? It's the future home of Tom's Toys. (Author's collection.)

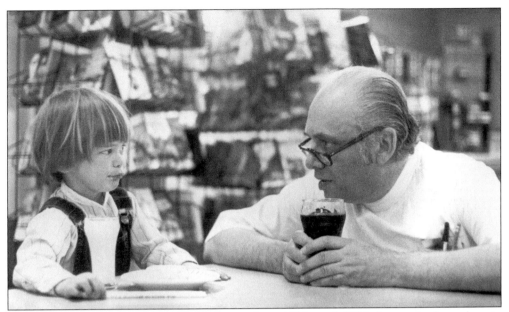

Harper's Pharmacy was a Main Street fixture from 1899 until 1986. It was the best place in town for sighting celebrities such as Norman Mailer, Harry Belafonte, Anthony Perkins, and Margaret Hamilton (the Wicked Witch of the West). Over the years, many important conversations were held at the lunch counter, including this 1980 discussion between pharmacist Bernard Green and Joshua Jones. (Don Victor photograph.)

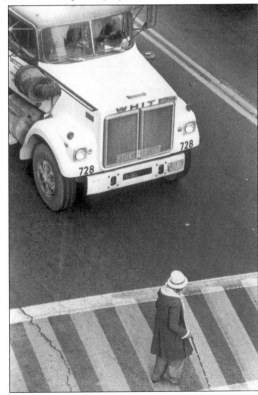

If we read between the lines, this Main Street crosswalk becomes a symbol of freedom and equality. This dramatic 1978 photograph shows a powerful White truck yielding to Carrie York, an African American. (Don Victor photograph.)

At Great Barrington's annual Summerfest celebration, spray cans of silly string mean fun for some and annoyance for others. (Author's collection.)

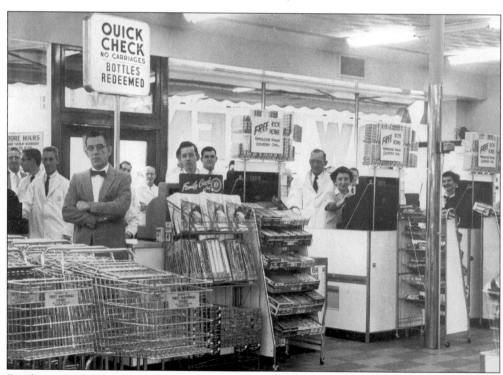

Employees at the First National Supermarket on Main Street guard their groceries in this 1950s scene. Note the signs offering a free ride home. (Marie Tassone photograph courtesy of the Great Barrington Historical Society.)

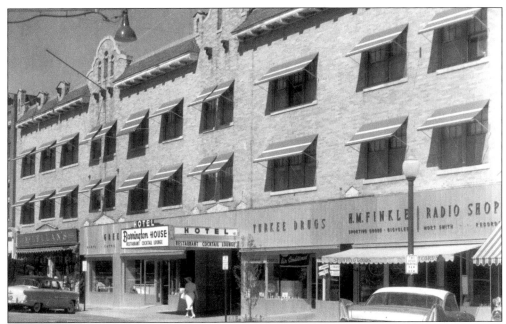

Main Street has changed dramatically since this photograph was taken in the 1950s. The Barrington House was originally known as the Hotel Miller. It was built in the 1850s with spacious open balconies that extended over the sidewalk. The building was remodeled in the late 1920s with the Spanish-style facade shown here. (Marie Tassone photograph courtesy of the Great Barrington Historical Society.)

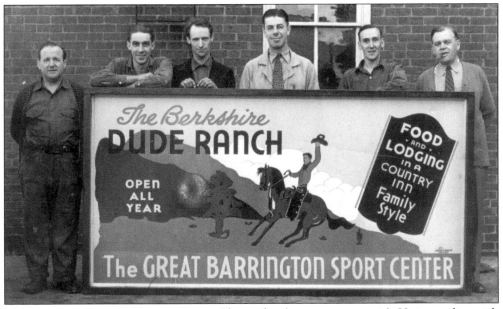

Meet sign painter extraordinaire Harvey Chittenden (center, wearing tie). He is standing with friends behind the old bank building, next to the current Carr Brothers Hardware. Chittenden created this sign for the Berkshire Dude Ranch, which was also known as the G-Bar-S Ranch and is today the Butternut Ski Area. Standing on the far right is Pete Adams. (Courtesy of the Great Barrington Historical Society.)

Despite the deadly Dutch elm disease, stately elms still graced Great Barrington's downtown in the 1950s. This is an early view of Great Barrington Savings Bank, now Berkshire Bank. (Clemens Kalischer photograph.)

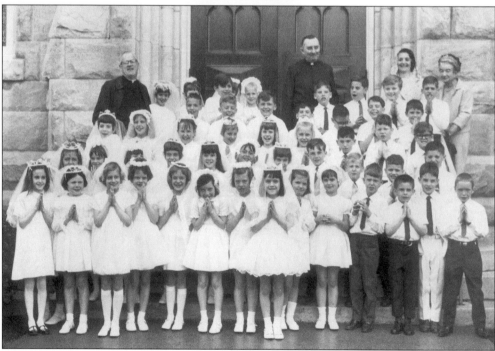

Route 7 never looked more heavenly than when these angels from St. Peter's church posed for their First Communion picture. (Marie Tassone photograph courtesy of the Great Barrington Historical Society.)

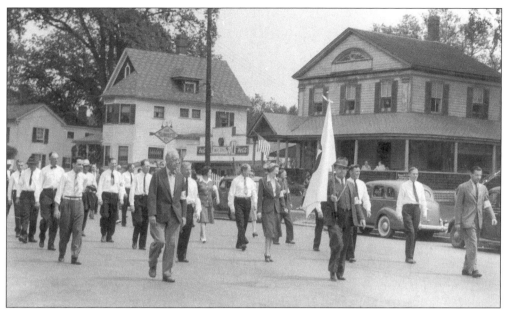

Only longtime residents would recognize the section Main Street where this parade took place. If you stood on this spot today, you would see Brooks Pharmacy. Tinker's Sunoco is shown in the background with Rosalie Gibbon's Beauty Shop on the right. The building to the left of center still stands and is now home to the Orion Society, a nature preservation group. (Courtesy of the Great Barrington Historical Society.)

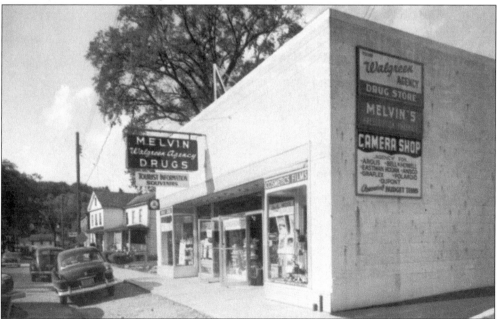

"If you can't find it at Melvin's, you don't need it!" That expression, along with several variations, confirmed that owner Melvin Katsh operated much more than just a pharmacy. His store was an institution on Main Street for more than 30 years. Katsh expanded operations several times until a devastating fire struck in 1978. The indefatigable entrepreneur rebuilt his store and ran it for several more years before selling it to Brooks Pharmacy. (Author's collection.)

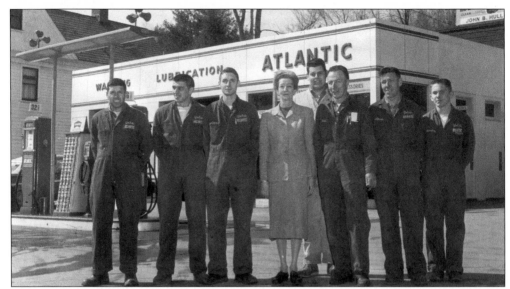

This site on Main Street is currently home to Cumberland Farms. When the above photograph was taken in 1960, the building was an Atlantic gas station. Standing ready to serve are, from left to right, Tom Kotleski, Don House, Dave Dobson, Millie Yates, John Ferron, Curt Yates, Lou Daigle, and Jim Lavalette. By the early 1970s, the site was occupied by Werner's Garage, shown below. In 1975, Cumberland Farms acquired the station and remodeled it into a convenience store. When the building was torn down in September 2000 to make way for a larger Cumberland Farms store, a portion of the old Atlantic station's overhead garage doors were found hidden above the drop ceiling. The old hydraulic car lift was also found under the concrete floor. (Aigner photograph above courtesy of the Great Barrington Historical Society; Overmyer photograph below courtesy of the *Berkshire Eagle*.)

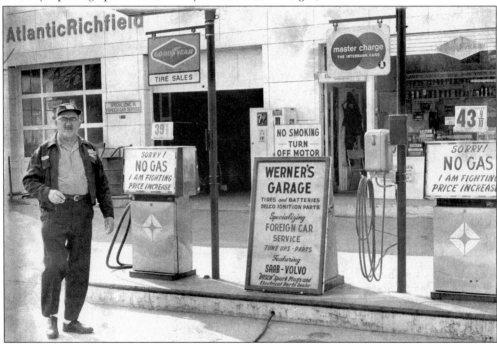

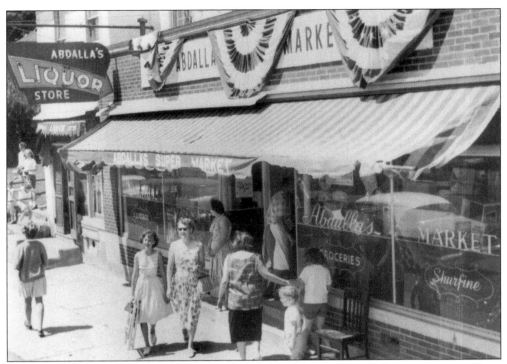

The original portion of this store is one of the oldest commercial structures on Great Barrington's Main Street. It is now home to Domaney's Discount Liquors. (Marie Tassone photograph courtesy of the Great Barrington Historical Society.)

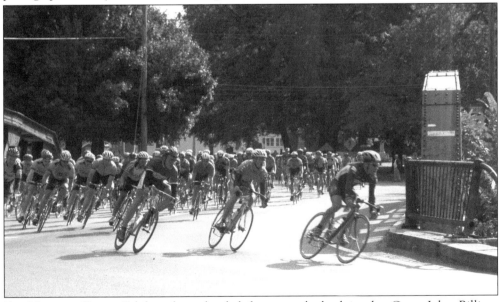

For 25 years, Route 7 bikers have battled for an early lead in the Great John Billings Runaground. The popular triathlon is named after Josh Billings, a 19th-century Berkshire humorist who proclaimed, "Tu sta is tu win." The modern translation is, "To finish is to win." (Kevin Sprague–Studio Two photograph courtesy of June Roy-Martin and the Great Josh Billings Runaground Committee.)

"Excuse me, ma'am, but I think you left this shampoo bottle in the shower at mother's motel." No, the Bates Motel is not on Route 7, but a big portion of the 1968 cult classic *Pretty Poison* was filmed alongside the highway in the summer of 1967. The psychological thriller stars Anthony Perkins as a naive parolee who falls in love with a beautiful but insanely manipulative teenager, played by Tuesday Weld. This photograph was taken next to the brown bridge on State Road. (Author's collection.)

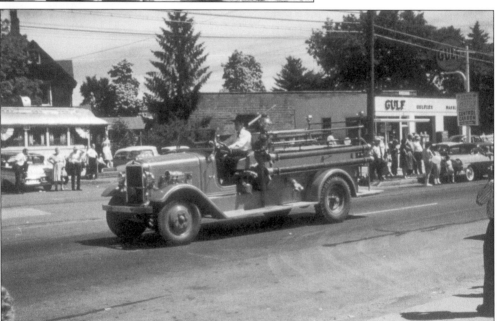

This is the only known photograph of the old trolley-style diner on State Road. It was taken during Great Barrington's bicentennial parade in 1961. The eatery had numerous names, including Martin's, Broverman's, and Murray's. After several small fires, the diner was finally torn down. Had it survived, it would have likely been a popular place today. The Gulf station is now Uncle Benz Auto Repair. (Isaline Bouteiller photograph from the author's collection.)

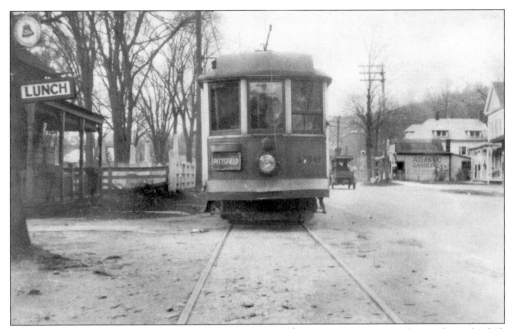

This trolley stop was located on State Road in Great Barrington. The lunch stand on the left was torn down long ago, and Broverman's Market (now the Pizza House) was built on the site. The Atlantic gas station on the right eventually became the Little Store antique shop. That building was razed in the mid-1990s. (Author's collection .)

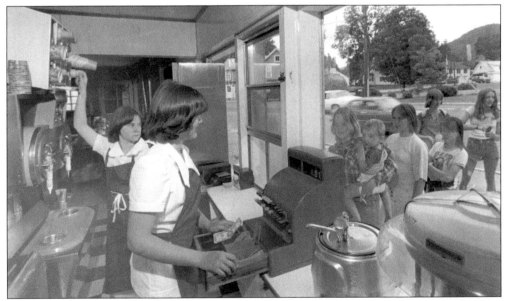

Eager customers line up outside of the Dairy Queen on a hot summer day. Located at the intersection of Routes 7 and 23 East, the popular ice cream shop kept customers cool from the 1950s until the 1980s. This photograph was taken in 1978. The building was later reincarnated as DJ's American Grill and now houses an antiques shop. (Don Victor photograph.)

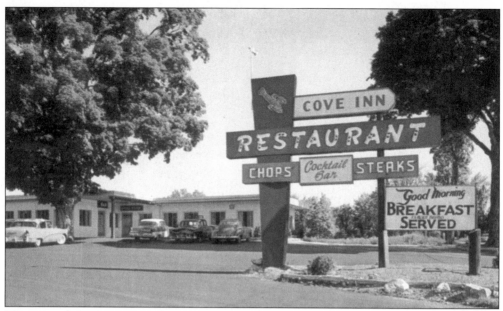

The original Cove Inn was a large, Colonial-style house. It was named after a nearby oxbow-shaped cove that formed when the Housatonic River was dammed up south of the site. In the 1950s, the building was badly damaged by fire but was rebuilt into the restaurant shown here. The Cove Bowling Lanes were added in 1960. (Author's collection.)

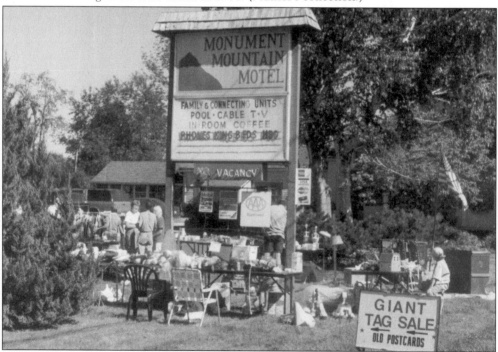

During the summer months, tag sale signs sprout up like dandelions along Route 7. As Saturday morning bargain hunters scurry from yard to yard in search of treasure, scenes like this one are common. Is that an old Shaker chair hiding behind the pine tree? Hurry! It's only $10. (Author's collection.)

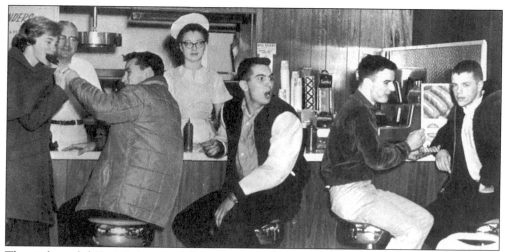

The pink-roofed Dari-Delite snack bar was originally near the edge of Route 7. It was shuffled back several hundred yards when the Grant City (now Kmart) Shopping Center was built. The A-framed building later served as a package store and video rental shop before it was torn down. Showing off in this 1966 photograph of the eatery are, from left to right, Sally Stevens, Horace Decelles, Bob Gay, Jean Ebitz, David Pevzner, David Thorne, and Mike Benham. (Courtesy of the Mason Library.)

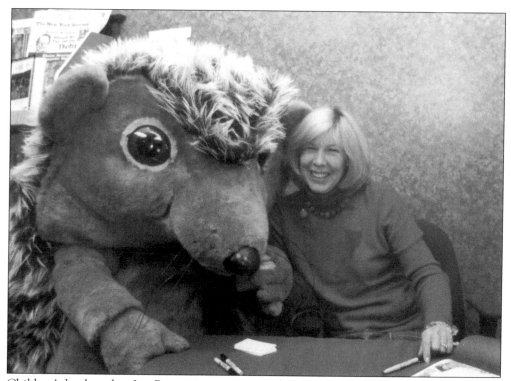

Children's book author Jan Brett joins summer resident Hedgie the Hedgehog at the Bookloft to sign copies of Brett's new book, *Hedgie's Surprise*. The Bookloft has been a success story on Route 7 for more than 25 years. (Julie McCarthy photograph.)

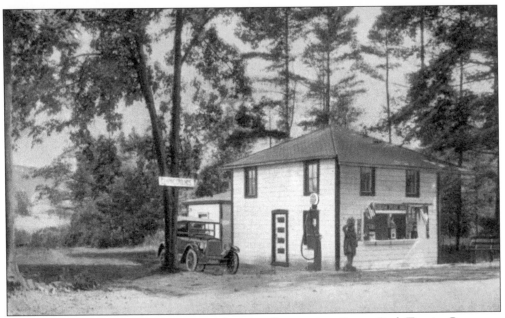

Located along Route 7 near Monument Mountain Reservation, Squaw Peak Tourist Camp was a scenic stopover for Berkshire visitors. The cabins, campground, snack bar, souvenir stand, and gas station were owned by the Ed Damms family until the early 1950s. Briarcliff Motor Lodge was built just north of the site in 1961. (Author's collection.)

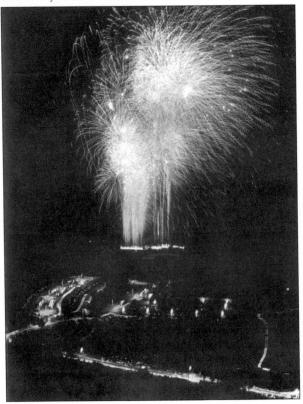

This spectacular pyrotechnic display was captured on film from high atop Monument Mountain. The fireworks were launched from the athletic field behind the high school. (Don Victor photograph.)

Five

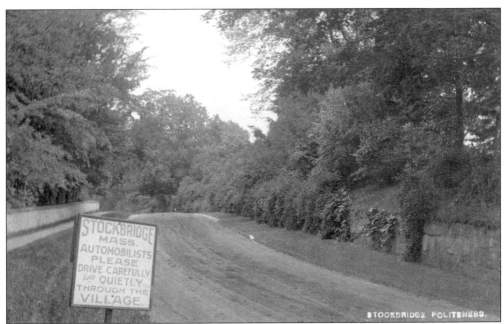

Where is everybody? The next time you find yourself sitting in summertime traffic, think of this photograph. (Courtesy Stockbridge Library Association.)

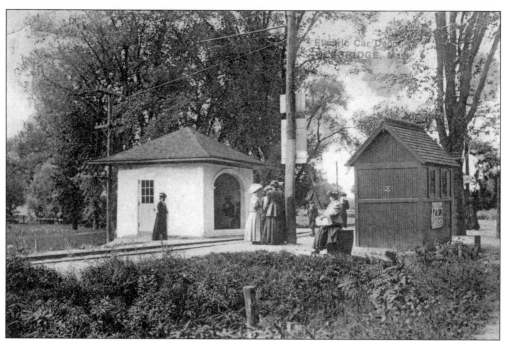

Shown in 1908, this cozy trolley station still stands on the corner of Route 7 and Park Street. It is now used for storage by the Stockbridge Parks and Recreation Department. (Author's collection.)

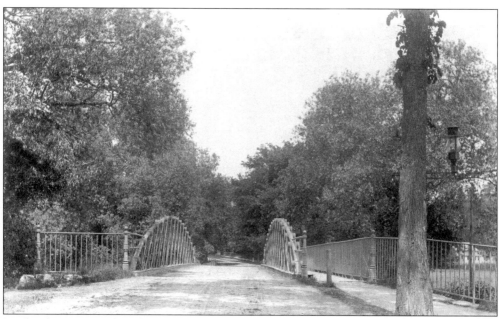

It is hard to imagine that the main road into Stockbridge once looked like this. You are looking north toward town in this rare 1890s view of the Housatonic River bridge. (Kendall photograph courtesy of David Gilmore.)

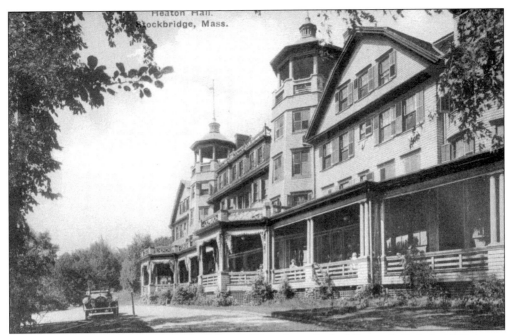

For nearly 70 years, the impressive Heaton Hall hotel overlooked Route 7. Built in 1903, it was frequented by the rich and famous. By the 1960s, however, the venerable inn had fallen on hard times and into disrepair. It was torn down in 1972. Today, a modern complex for senior citizens occupies the site. (Author's collection.)

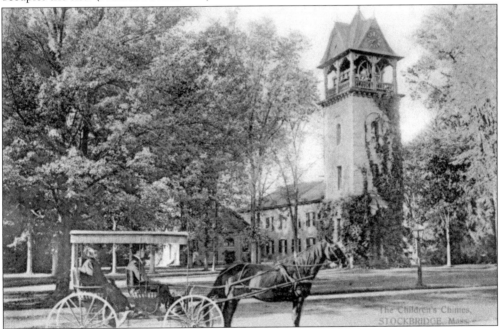

Just a short gallop west of Route 7 is the Children's Chime Tower. It was given to the town of Stockbridge in 1878 by noted attorney David Dudley Field. (Field's brother Cyrus built the first transatlantic telegraph cable.) Tradition has it that the tower marks the spot where missionary John Sergeant preached to Stockbridge Native Americans in 1739. (Author's collection.)

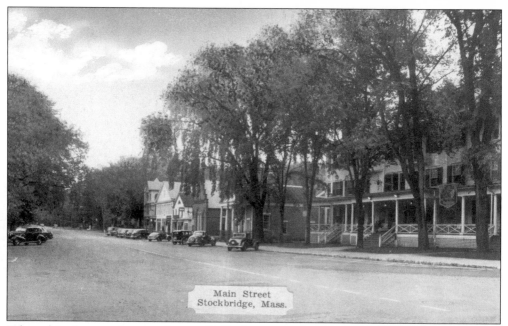

Main Street
Stockbridge, Mass.

When this photograph was taken c. 1940, downtown Stockbridge had more elm trees than automobiles. The Red Lion Inn, shown at right, first opened for business c. 1778 as Bingham's Tavern. Today, the inn is operated with loving care by the Fitzpatrick family and a staff of dedicated employees. (Author's collection.)

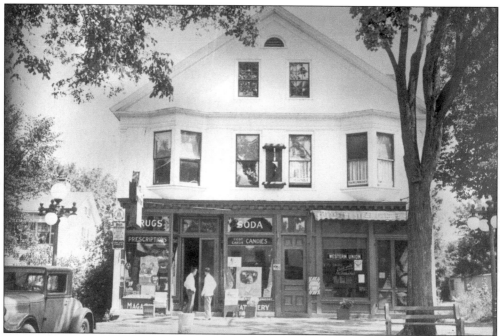

Benjamin's Drugstore was one of the most popular spots in town. Located on the north side of Main Street, the building also housed the Western Union office and a barbershop. Today it is home to Minkler Insurance and Daily Bread Bakery. (Courtesy of the Stockbridge Library Association.)

64

The old Stockbridge town hall is decorated for the Fourth of July in this 1920s photograph. The building now serves as the studio of renowned photographer Clemens Kalischer as well as a Yankee Candle Company store. (Courtesy of the Stockbridge Library Association.)

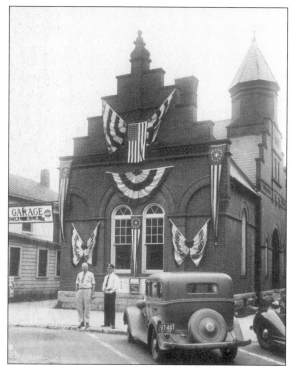

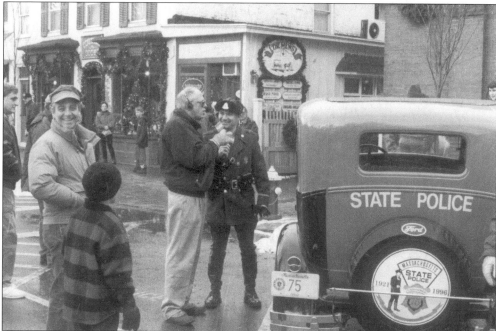

In this 1990s photograph, a classic police cruiser is parked in nearly the same spot as the vehicle shown in the top photograph. Both images also feature a policeman. This photograph was taken during the Norman Rockwell Christmas-on-Main-Street celebration that is held annually in downtown Stockbridge. WSBS radio personality Nick Diller is shown trying to talk his way out of a parking ticket. (Author's collection.)

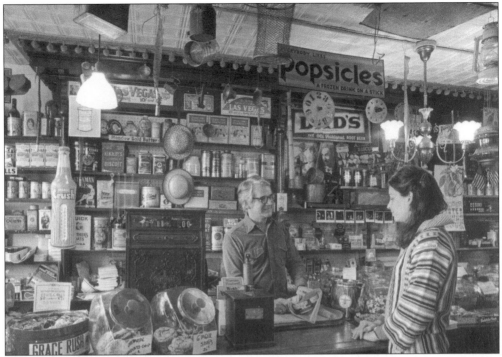

Welcome to Williams & Sons Country Store. Things have not changed much since this picture was taken more than 20 years ago. Here, former owner Phil Creelman chats with Sally Underwood Johnson. (Clemens Kalischer photograph.)

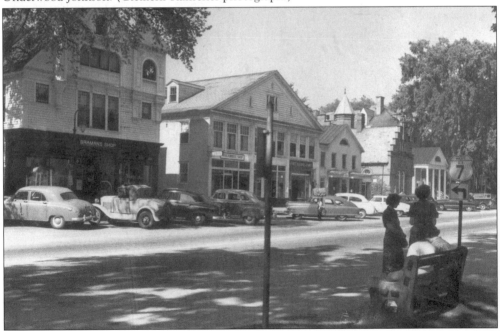

Many refer to downtown Stockbridge as "Norman Rockwell's Main Street." This summertime view was taken in the early 1950s. (William Scovill photograph courtesy of the Stockbridge Library Association.)

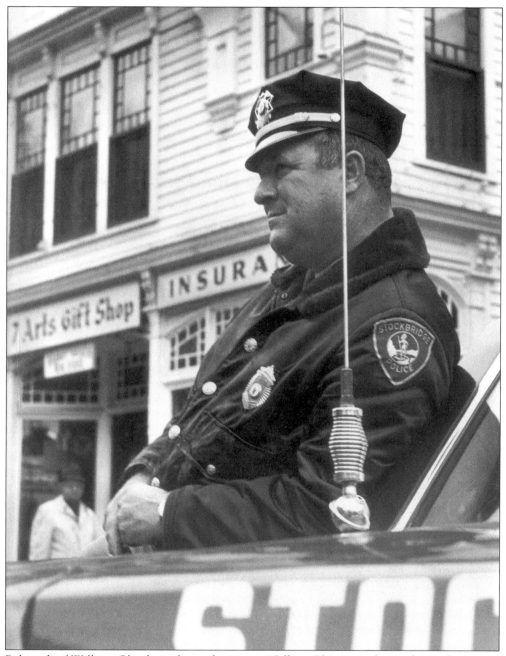

Police chief William Obenhein, better known as "Officer Obie," stands guard over downtown Stockbridge. He seems to be on the alert for an invasion of hippy freaks heading for Alice's Restaurant. Those unfamiliar with this story should listen to Arlo Guthrie's classic song "Alice's Restaurant Massacree" or watch the 1969 film. (Clemens Kalischer photograph.)

Is everybody at Tanglewood? If not for the well-known gargoyle water fountain, this 1890s Main Street view of Stockbridge would be nearly unrecognizable. (Kendall photograph from the author's collection.)

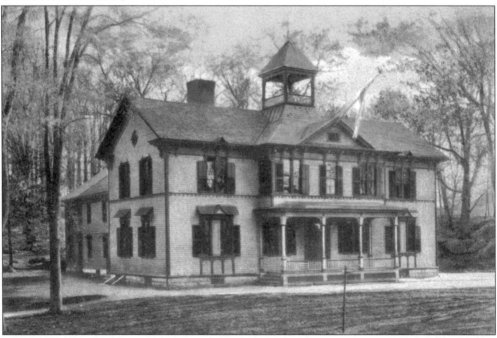

The Williams Academy on Main Street served local students for many years. By the turn of the 19th century, however, the old school was worn out. In 1913, a new Williams High School was built in front of the old academy building. The new brick building, which served as the high school until 1967, now houses the Stockbridge Plain School. (Author's collection.)

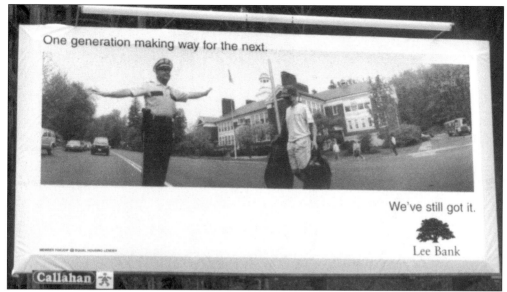

Officer Louis Peyron is the top cop in this clever billboard advertisement for Lee Bank. The panoramic view was taken on a Route 7 crosswalk near the Stockbridge Plain School. The billboard appeared along Route 7 in Great Barrington. (Courtesy of Mick Callahan and Callahan Outdoor Advertising.)

A few miles north of Stockbridge is this pleasant reminder of Route 7 at its best. (Clemens Kalischer photograph.)

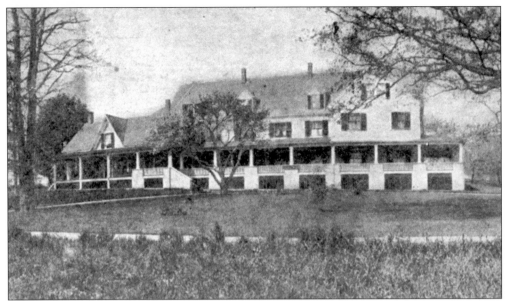

The Oak Lawn House was built in the 1890s. The structure was greatly expanded in the 1930s and reopened as a hotel. The site, however, is best known as Beauprè, a creative and performing arts center that opened in 1958, offering studies in dance, drama, and art. The building still stands partially hidden by a stand of pine trees on the west side of Route 7. (Courtesy of Judy Rupinski.)

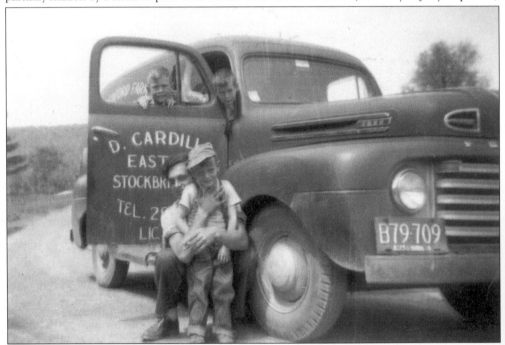

Milkman Chuck Cardillo gets help from Bobby, Joe, and Bill Sinico in this 1952 view. Chuck and his father, Dominick Cardillo, operated Redford Farms Dairy on East Street (Route 7 north of Stockbridge). Originally known as the Wallace Dairy, the property was sliced in two when the Massachusetts turnpike was built in the mid-1950s. (Photograph courtesy of Debbie Cardillo Caffrey.)

The festive Christmas Tree Inn stood atop a knoll along Route 7 between Stockbridge and Lenox. Surrounded by ancient evergreens, the 19th-century structure burned down in 1975. (Author's collection.)

Christmas Tree Inn

ROUTE #7 ·-· TELEPHONE 13

Stockbridge, Massachusetts

MARJORY AND GIFFORD MABIE

Dining rooms are available for private parties.
Skiing parties arriving by train will be met upon request and transportation furnished to ski tows.

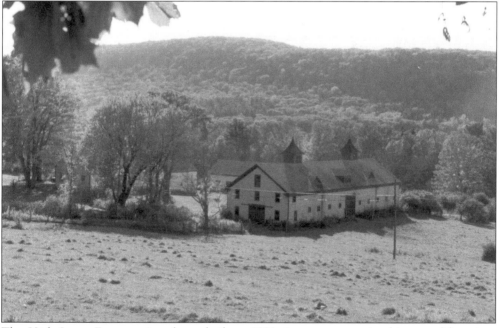

The High Lawn Farm carriage barn, built c. 1891, is center stage in this peaceful setting. Rattlesnake Mountain rises in the background. Sadly, pastoral views like this are dwindling along Route 7. (Author's collection.)

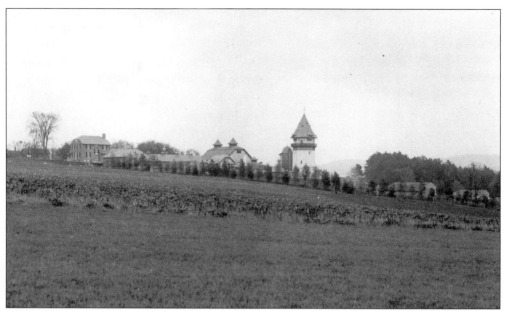

This view of High Lawn Farm in Lee was taken soon after construction of the pointed clock tower was completed in the early 1900s. The Clifford Construction Company of Lenox built the structure, which is actually a beautifully disguised water tower. Roy Adams of Lee was the construction foreman for the job, and his grandson preserved this photograph. (Courtesy of Mark Withers and David Klausmeyer.)

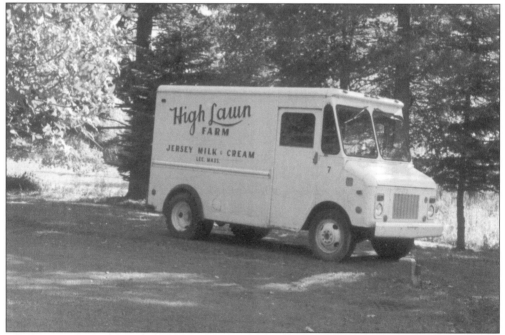

Berkshire visitors are often amazed to discover that High Lawn Farm in Lee still makes home deliveries. The farm was founded in the 1800s and enlarged when Col. H.G. Wilde and Marjorie Field Wilde assumed ownership from Mrs. Wilde's family. High-quality Jersey milk has been the mainstay of High Lawn Farms for nearly a century. (Author's collection.)

Six

ENTERING LENOX

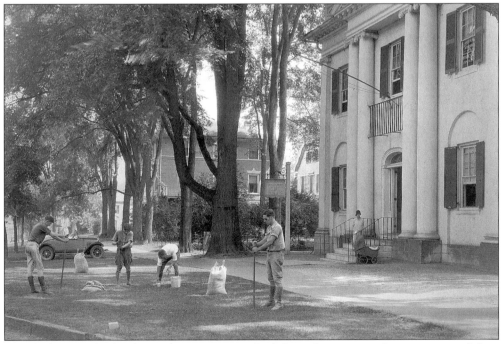

Long before Dutch elm disease began to ravage Berkshire elm trees, residents appreciated their beauty and grace. In this rare photograph, Lenox residents use a technique called "the Bartlett method" to feed elms in front of the Lenox Library. Today, the few surviving elms along Route 7 are monitored, treated, and protected by Elm Watch, an organization headed by Tom Zetterstrom of Canaan, Connecticut. (Courtesy of the Lenox Historical Society.)

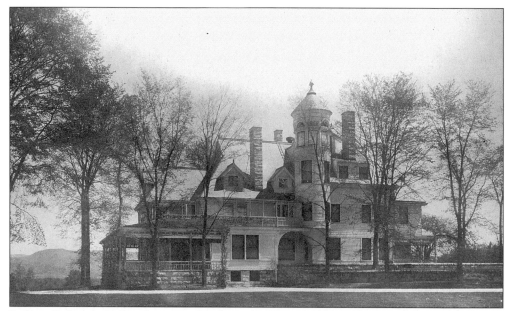

Erskine Park was the lavish estate of industrialist George Westinghouse. Built in 1893, it was torn down in 1919 by new owner Margaret McKim Vanderbilt, who proclaimed it to be "horribly Victorian." Today this site is home to the Ponds at Foxhollow, a timeshare resort. (Courtesy of Virginia Larkin.)

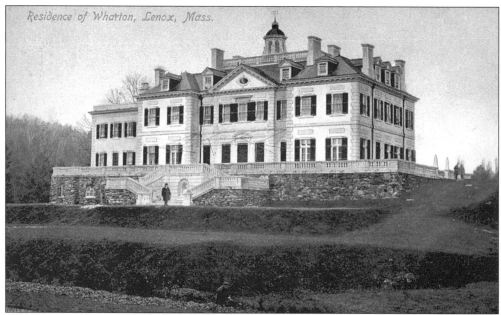

The Mount was the summer home of Pulitzer Prize–winning author Edith Wharton (1862–1937). Wharton was a principal designer of the mansion and the elaborate gardens that grace the property. The place is supposedly haunted, but Wharton has repeatedly denied that allegation whenever she materializes. The Mount is now a museum located at the corner of Plunkett Road and Route 7 in Lenox. (Courtesy of David Gilmore.)

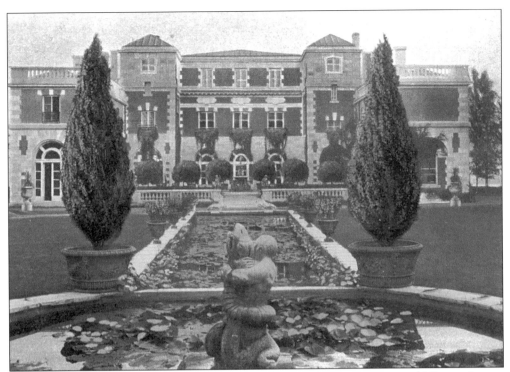

In 1897, New Yorker Giraud Foster built this modest summer cottage on old Route 7, now Kemble Street. He named it Bellefontaine and lived here until his death in 1945. The interior was destroyed by fire in 1949 and was then rebuilt as a Catholic seminary. It is now home to the Canyon Ranch resort. (Courtesy of the Berkshire County Historical Society.)

Giraud Foster's son "Boy" and his puppy pal look over the expansive gardens at Bellefontaine. "Boy" was a nickname that stuck with the junior Giraud for his entire life. (Courtesy of the Lenox Library Association.)

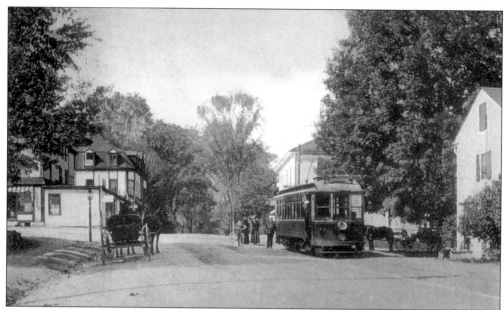

The Berkshire Street Railway trolley picks up passengers in downtown Lenox *c*. 1909. (Courtesy of the Berkshire County Historical Society.)

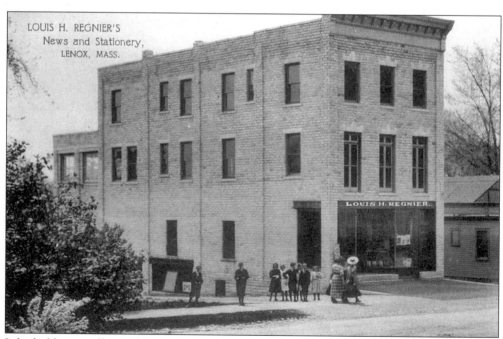

LOUIS H. REGNIER'S
News and Stationery,
LENOX, MASS.

LOUIS H. REGNIER

It looks like a small crowd has gathered at Regnier's Stationery Store. Maybe they have a lot to write home about. Today, the Tangle Wool clothing store occupies the building. (Courtesy of David Gilmore.)

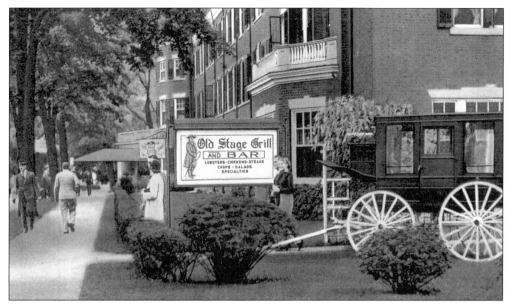

The Curtis Hotel in Lenox has existed in one form or another since the 1700s. A 20th-century addition was the Old Stage Grill and Bar. The place kept hungry customers happy for years. But how did they fit everyone into that stagecoach? (Courtesy Judy Rupinski.)

Some estimate that the picturesque Church on the Hill has been photographed about 21 trillion times since it was dedicated in 1806. Here is just one of those heavenly views. (Author's collection.)

Folks usually felt better after visiting Hagyard's Drugstore. Perhaps it was the combination of good medicine and personal service. The popular pharmacy was located at the corner of Main and Housatonic Streets. (Courtesy of David Gilmore.)

Check out the extensive stock in this interior view of Hagyard's Drugstore. Hagyard really knew how to display his merchandise. Would you like one of everything? (Author's collection.)

Lenox Academy was founded in 1803. A partial list of illustrious graduates includes Henry Shaw (also known as Josh Billings), Mark Hopkins, and Anson Jones (the last president of the Republic of Texas). The handsome clapboard structure is now home to the Lenox Historical Society. (Clemens Kalischer photograph.)

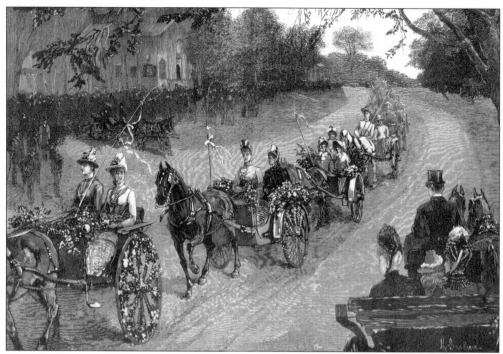

In the latter part of the 18th century, the social elite of Lenox celebrated summer's end with their annual Tub Parade. Curious spectators gathered along the roadside as horse-drawn carriages, lavishly decorated with foliage and flowers, paraded through town. In 1886, artist Henry Sandham illustrated the festivities for *Harper's Weekly*, as shown above. In the 1990s, the tub tradition was revived, and each September the Colonial Carriage & Driving Society gathers for a colorful reenactment, as shown below. (Above courtesy of Cormier's Art Gallery; below from the author's collection.)

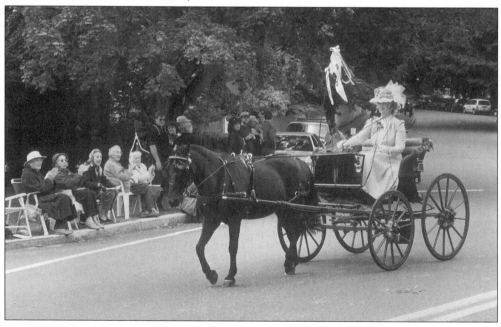

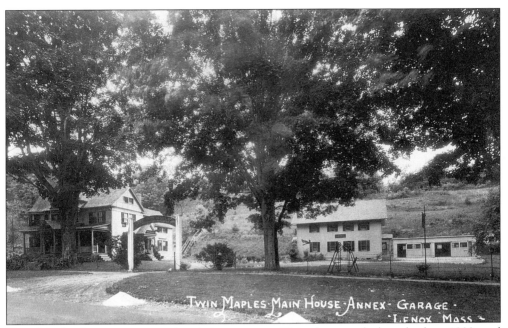

Twin Maples Inn got its name for obvious reasons. This photograph dates back to 1923, and the place is still in business as the Cornell Inn. (Author's collection.)

Originally known as Burke's Maple Tea Cabin, the name of this A-frame was later changed to the Log Cabin Restaurant. In recent years, the place was greatly expanded and is now the Lenox 218 Restaurant. (Courtesy of the Berkshire County Historical Society.)

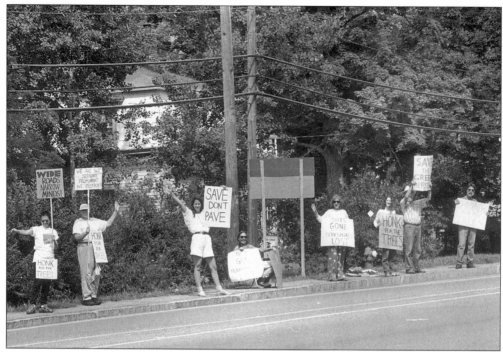

The building of a north-south bypass through Berkshire County has been debated off and on for 50 years. Since a consensus has never been reached, Route 7 has periodically been widened and adjusted. Several years ago, the Massachusetts Highway Department announced plans for a major widening of the road from Lenox to Pittsfield. Some local residents picketed and protested the extensive tree cutting, but the project proceeded. (Clemens Kalischer photograph.)

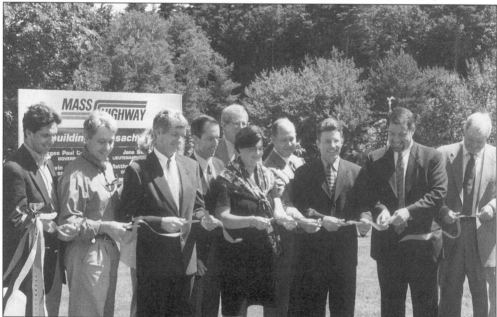

In this July 2000 picture, state and local officials gather for a ribbon-cutting ceremony to mark the completion of Route 7 construction from Lenox to Pittsfield. (Author's collection.)

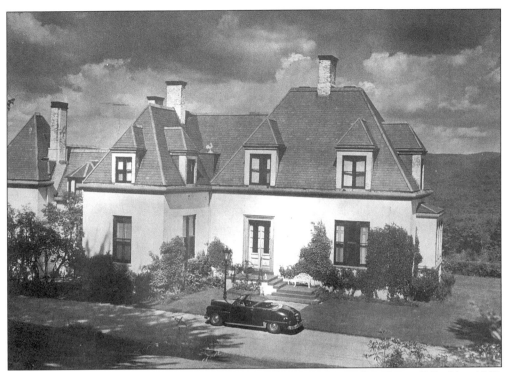

The French chateau-style Dormers mansion is a little-known treasure along Route 7. Build in 1868, the building remains hidden and protected by a small forest, although former frontage has been gobbled up by motels and commercials enterprises. (Courtesy of Wheeler and Taylor Realty.)

Does this place look familiar? Today, it is the popular Five Chairs Restaurant on Route 7. (Truth be told, they have more than five chairs.) The white horse standing behind the sign eventually wandered up Route 7 and is now hitched up in front of the Wagon Wheel Motel. (Courtesy of Virginia Larkin.)

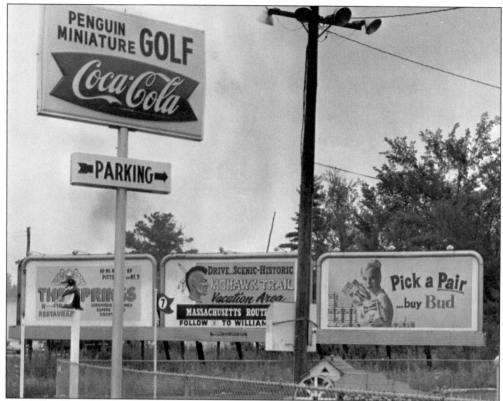

Folks still talk about the whimsical cement sea creatures at the old Penguin Miniature Golf Course. Located across from the Ames Shopping Center, the site is now occupied by a Burger King. (Courtesy of the *Berkshire Eagle*.)

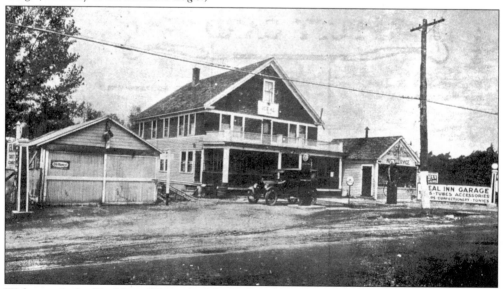

Welcome to the Ideal Inn. What was "ideal" about the place is hard to tell, but it was located in the general vicinity of the present-day Jiffy Lube, near the Lenox-Pittsfield town line. (Courtesy of Judy Rupinski.)

Seven

ENTERING PITTSFIELD

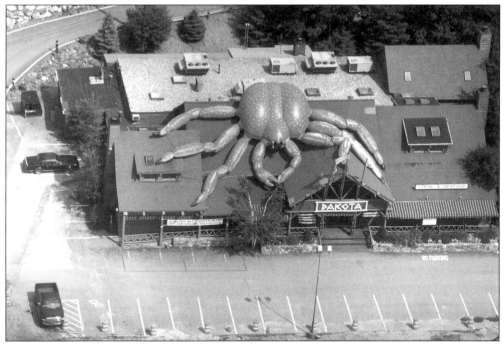

Who says fresh seafood is hard to find in the Berkshires? You just have to know where to look. What better place to find it than the roof of the Dakota Restaurant during its annual crab fest? (Don Victor photograph.)

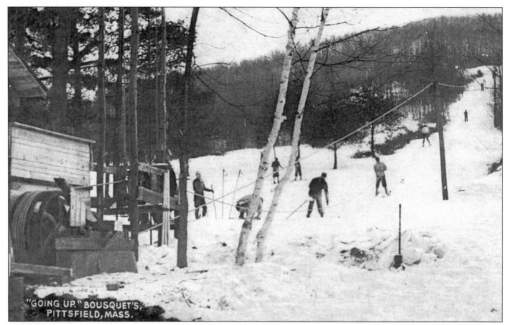

Things certainly have changed at Bousquet ski area since this old-time rope tow was the only way to the top. (Courtesy of the Berkshire County Historical Society.)

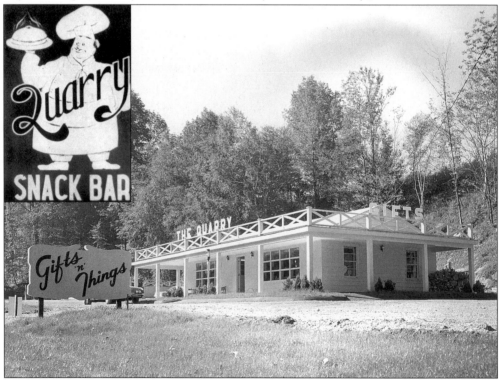

The Quarry was one of Pittsfield's early fast-food restaurants. Its next incarnation was as a gift shop. Since then, many different businesses have come and gone. The building is now home to the Berkshire Flower Company. (Art Marasco photograph.)

The Country Club of Pittsfield was founded in 1897 on the site of a farm once owned by Herman Melville's uncle. The clubhouse has been expanded and remodeled many times since this early-1900s photograph was taken. (Courtesy of Judy Rupinski.)

When Pittsfield's Colonial Theater opened in 1903, it was big news. The building has returned to the headlines in recent years as well. First Lady Hillary Clinton visited the Colonial in 1998 and declared it a "national treasure." Efforts to restore the theater (most recently the home of Miller Art Supply) continue to move forward. (Author's collection.)

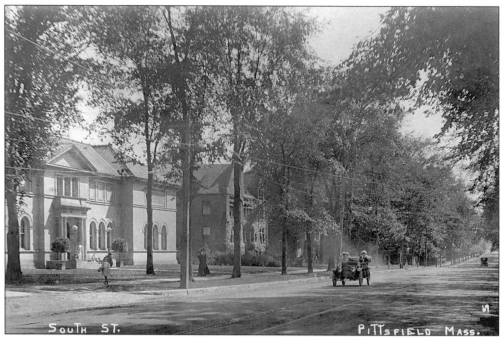

The Berkshire Museum is surrounded by shade trees in this early-1900s photograph. The "dinosaur" driving by is quite different than the Stegosaurus that stands out front today. (Courtesy of Virginia Larkin.)

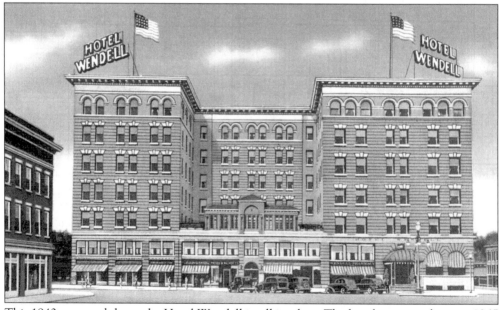

This 1940s postcard shows the Hotel Wendell in all its glory. The hotel was torn down in 1965 to make way for the Berkshire Common and the current Crown Plaza Hotel. (Courtesy of Virginia Larkin.)

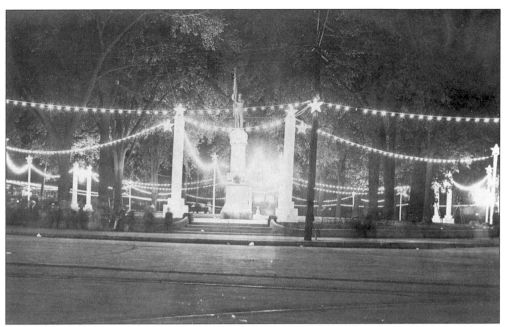

Park Square is illuminated with holiday spirit in this 1911 picture. (Courtesy of Judy Rupinski.)

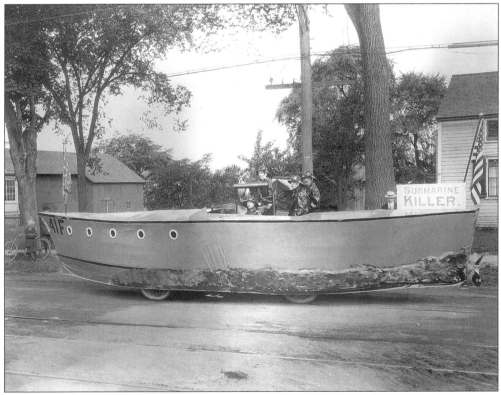

Sailors on East Street prepare to search for enemy submarines on North Street as floats line up for a World War I bond drive parade. (Courtesy of the Berkshire County Historical Society.)

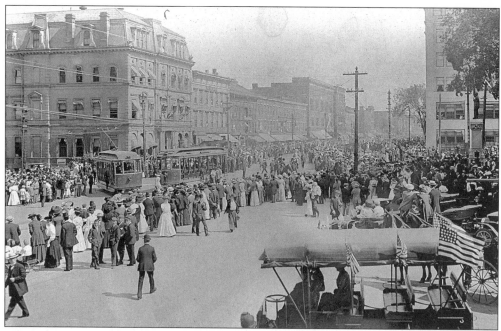

Old automobiles and trolley cars are shown in this early-1900s view of North Street. The former Berkshire Life Insurance building is in the background. (Courtesy of Judy Rupinski.)

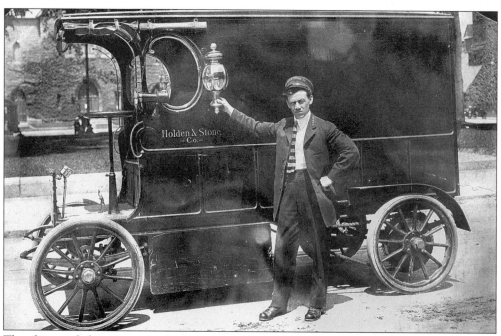

The driver of this vintage vehicle prepares to make deliveries for the Holden & Stone Department Store on North Street. (Courtesy of Judy Rupinski.)

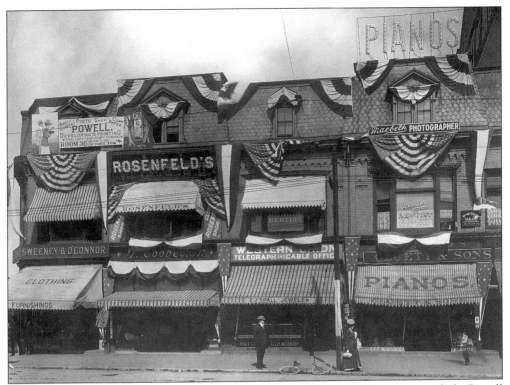

This view depicts the old Miller Building at 184 North Street. Businesses include Powell Photography, Sweeney & O'Connor, Rosenfeld's, Cooney Jr., E.J. Spall Jeweler, Cluett & Sons Music, Macbeth Photography, Western Union Telegraph, Robinson Dentist, and McGavin Tailor. (Powell photograph courtesy of Virginia Larkin.)

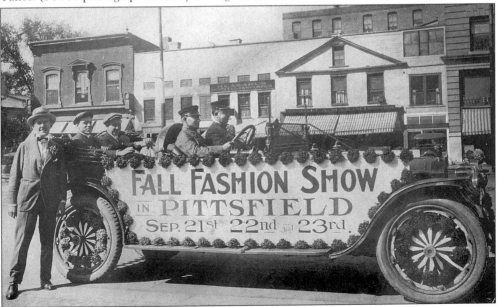

These men are ready to check out the new fall fashions in Pittsfield *c.* 1920. (Benedict photograph courtesy of Judy Rupinski.)

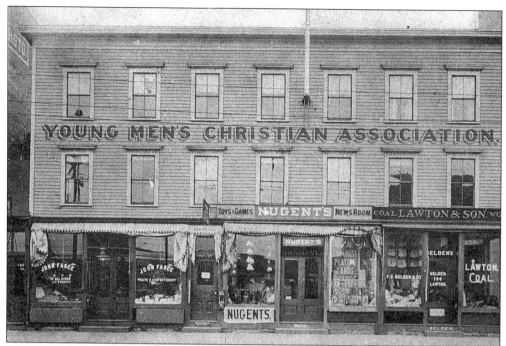

Shown is the Young Men's Christian Association (YMCA) building in 1917. Storefront shops include John Fasce Grocery, Nugent's News Room, and the Lawton Coal Company. (Courtesy of Judy Rupinski.)

If you ask nicely, he might take you for a spin. (Courtesy of the Berkshire County Historical Society.)

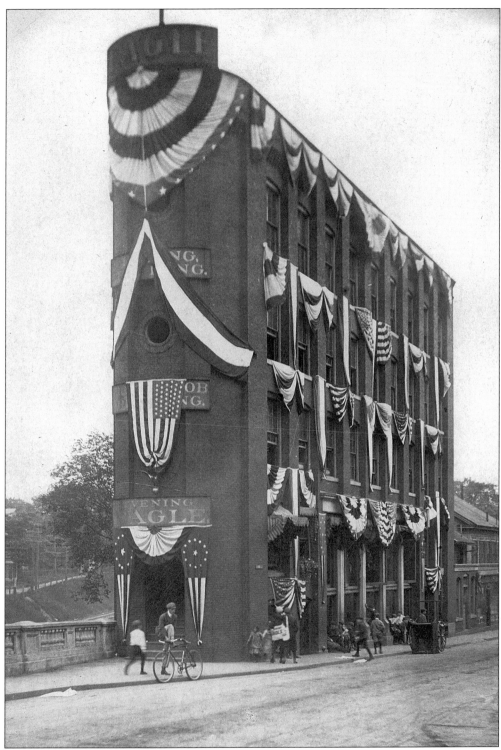

The Berkshire Eagle building is all decked out for a holiday celebration in this early-1900s view. (Courtesy of Reliable Sources.)

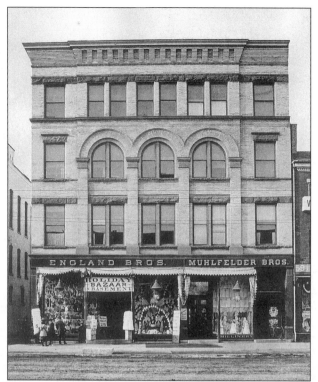

The England Brothers Department Store began as a small dry-goods shop in 1857. By the time it closed in 1988, it had become one of the oldest family-owned department stores in the United States. This early view of the store was taken in 1886. (Courtesy of the Berkshire County Historical Society.)

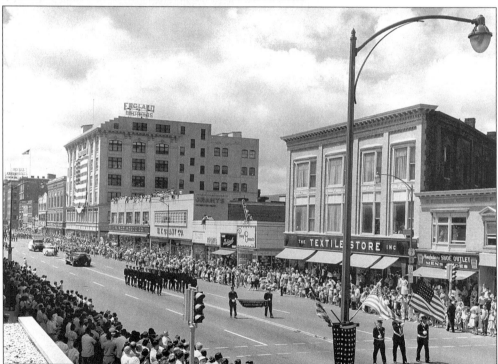

Crowds line North Street in 1957 to watch a firemen's muster parade. (William Tague photograph courtesy of the Berkshire County Historical Society.)

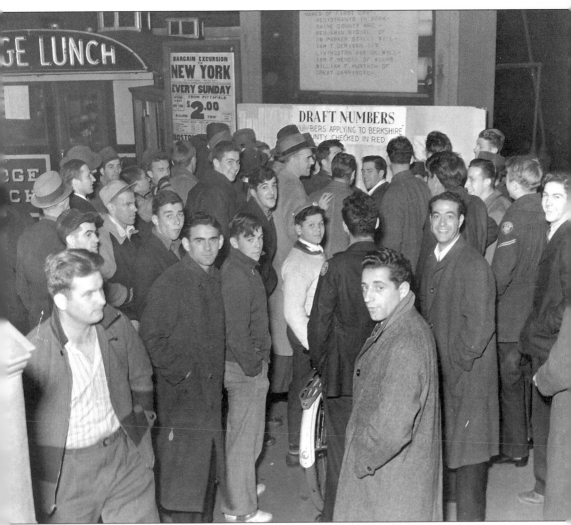

Local residents gather around the latest draft number postings in this 1940s view taken next to the Bridge Lunch Diner on North Street. (Courtesy of the *Berkshire Eagle*.)

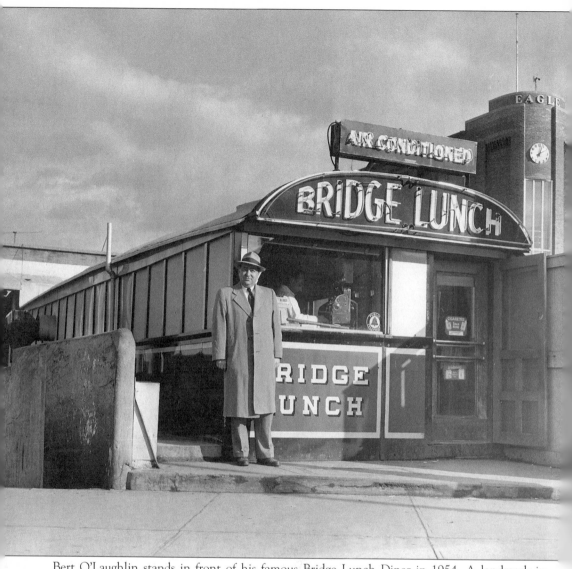

Bert O'Laughlin stands in front of his famous Bridge Lunch Diner in 1954. A landmark in downtown Pittsfield, the diner was demolished in 1982 to make way for reconstruction of the North Street railroad underpass. (Bill Mahan photograph courtesy of the *Berkshire Eagle*.)

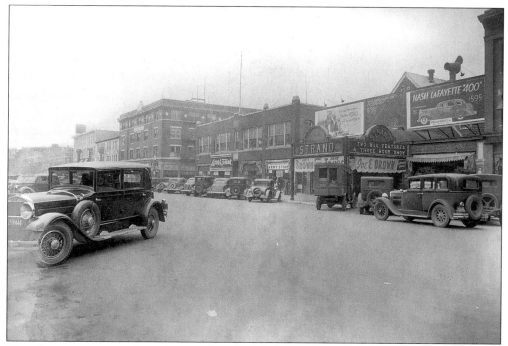

If we hurry, we can still catch comedian Joe E. Brown (and his big mouth) at the Strand Theater. Or we can just walk around and check out all these cool cars. (Courtesy of Callahan Outdoor Advertising.)

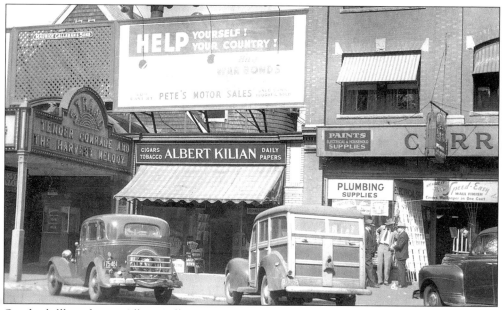

On the billboard over Albert Killian's store, Pete's Motors encourages folks to buy war bonds during World War II. (Courtesy of Callahan Outdoor Advertising.)

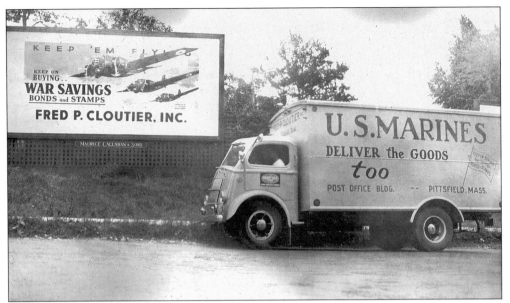

The U.S. Army Air Corp, the U.S. Marines, and Fred Cloutier team up to support the war effort. (Courtesy of Callahan Outdoor Advertising.)

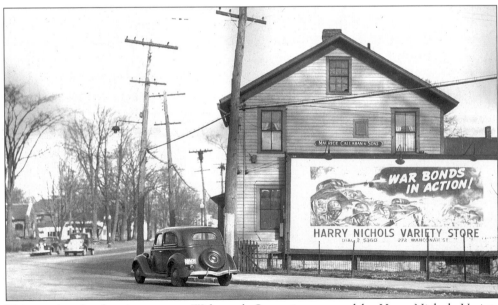

This war bonds advertisement on Wahconah Street is sponsored by Harry Nichols Variety Store. (Courtesy of Callahan Outdoor Advertising.)

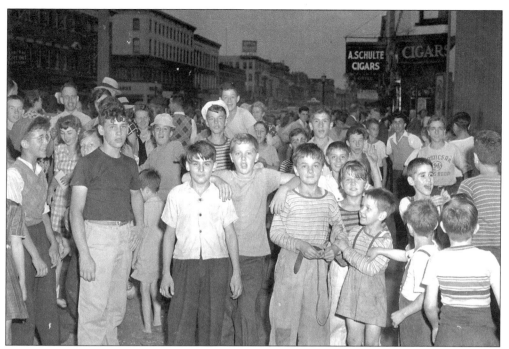

Youngsters gather near the *Berkshire Eagle* bulletin board as word arrives of the Japanese surrender, marking the end of World War II. (Courtesy of the *Berkshire Eagle*.)

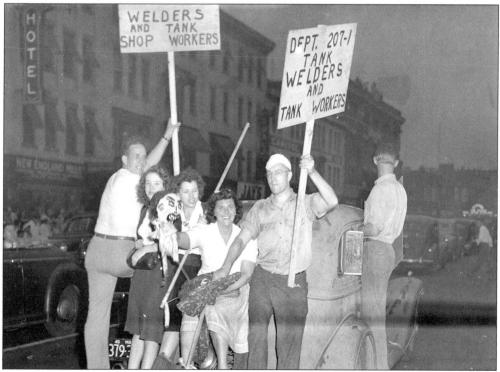

As the end of World War II is announced, a group of tank builders celebrate on North Street. (William Plouffe photograph courtesy of the *Berkshire Eagle*.)

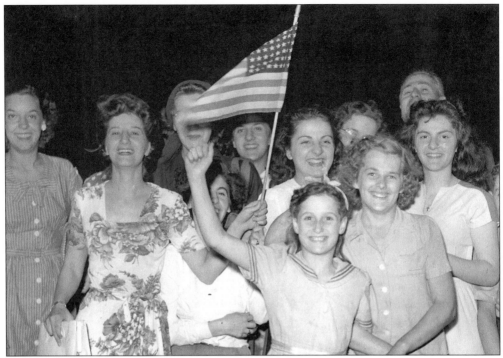

Elated Pittsfield residents take to the streets on V-J Day to celebrate the end of World War II. (Courtesy of the *Berkshire Eagle*.)

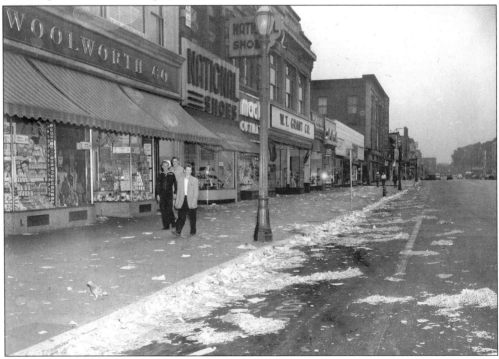

North Street is awash in a sea of confetti on the morning after V-J Day celebrations marked the end of World War II. (Courtesy of the *Berkshire Eagle*.)

Does anybody remember the old A & P grocery store on the upper end of downtown Pittsfield? This site is now home to the Central Tractor Farm & Country Store. (Courtesy of Callahan Outdoor Advertising.)

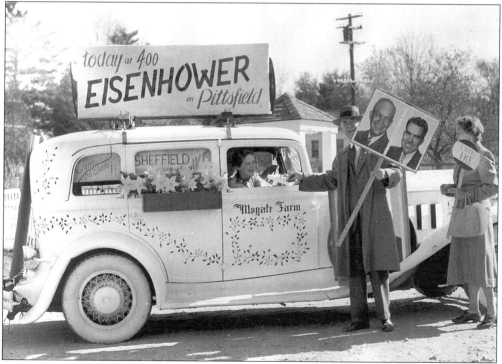

Eisenhower fans from Mogate Farms in Sheffield prepare to meet and greet the popular presidential candidate in Pittsfield. (Tassone photograph courtesy of the Great Barrington Historical Society.)

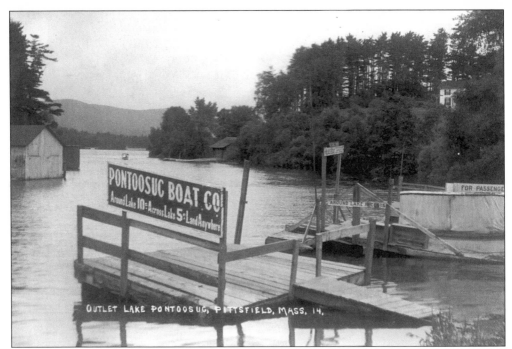

Care to go for a spin around the lake? In 1916, a one-way trip across Pontoosuc Lake cost only 5¢. A round trip was 10¢. Do you suppose they have a senior citizen's discount? (Courtesy of Judy Rupinski.).

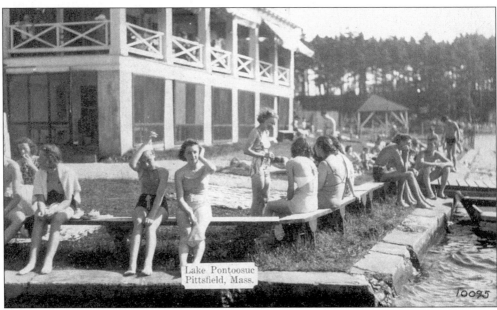

Pontoosuc Lake was the place to be on this hot summer day in the 1940s. (Author's collection.)

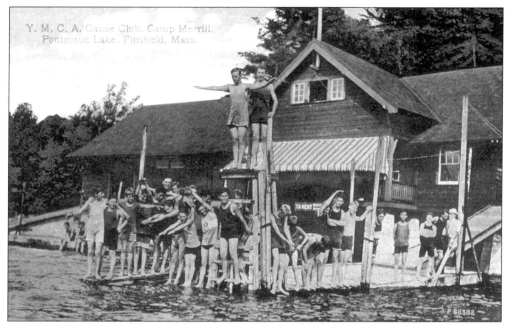

Let's see how many people we can fit onto the dock. The first one in is all wet. (Courtesy of Judy Rupinski.)

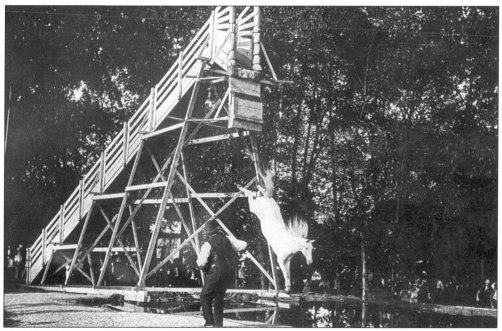

Hi-ho Silver, away! Even the Lone Ranger's horse cannot resist a swim on such a hot day. Actually, this early-1900s photograph shows the amazing diving horse of Pontoosuc Lake. (Author's collection.)

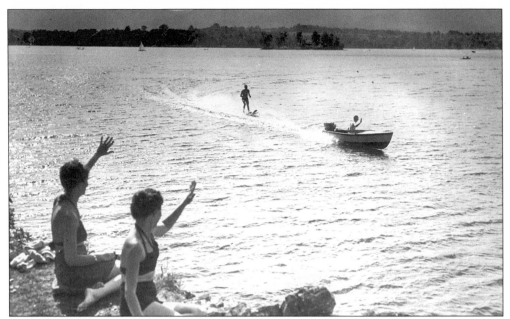

Skimming the waves is Carl White, the first known water skier in Berkshire County. The boat driver is Larry Phillips, and the lake is Pontoosuc. White first learned to "walk" on water while on a short vacation to Atlantic City, New Jersey, in the 1930s. In those days, the towrope was attached to the ski tips, and the skier held onto a separate rope also connected to the skis. An enlargement of this photograph was displayed in the front window at England Brothers Department Store many years ago. (William Plouffe photograph from the author's collection.)

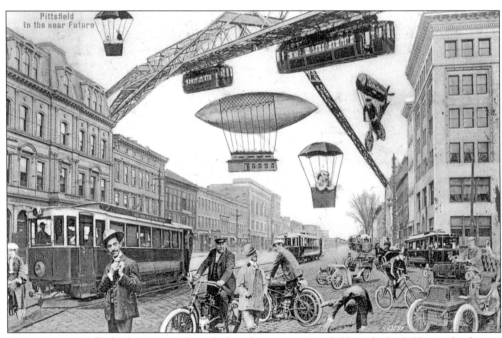

A century ago, folks had a strange idea of what downtown Pittsfield might look like in the future. Think how happy merchants would be if North Street was this busy today. (Author's collection.)

Eight

ENTERING

LANESBOROUGH
&
NEW ASHFORD

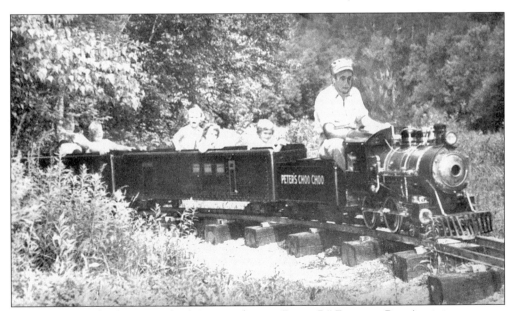

"I think I can, I think I can, I think I can make it to Route 7." Engineer Peter's miniature steam choo-choo train chugs along a narrow-gauge track just a stone's throw from Balance Rock in Lanesborough. (Courtesy of the Berkshire County Historical Society.)

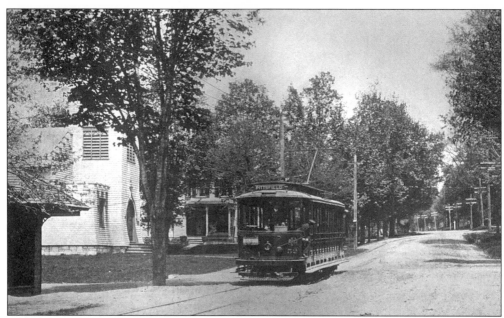

A Berkshire Street Railway trolley is rolling along Lanesborough's Main Street in this *c.* 1909 view looking north. It may have been the U.S. Post Office that first started using the abbreviated name "Lanesboro" for the town. However, many folks still prefer their Lanesborough with its "ugh." (Author's collection.)

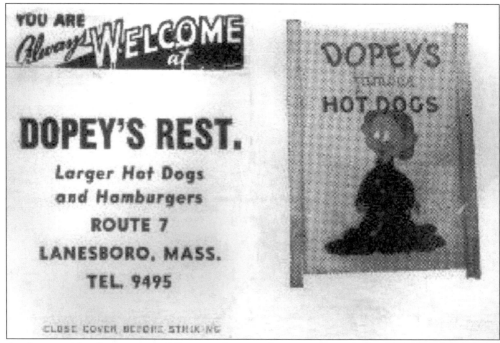

As the matchbook cover says, "You are always welcome at Dopey's Restaurant." The popular eatery was a favorite of Route 7 travelers until Grumpy and Sneezy began to frequent the place. Now that all the dwarves have retired, the restaurant is known as Bob's County Kitchen. (Author's collection.)

Josh Billings was the pen name of Henry Wheeler Shaw, a folksy humorist who was born in Lanesborough. His philosophical comments—written with a rural dialect, intentional misspellings, and fractured grammar—were widely popular after the Civil War through his newspaper pieces, books, and comic lectures. By 1867, he had become a national celebrity with such sayings such as, "I don't hanker to see a man who has more hair under his nose than knows under his hair." (Author's collection.)

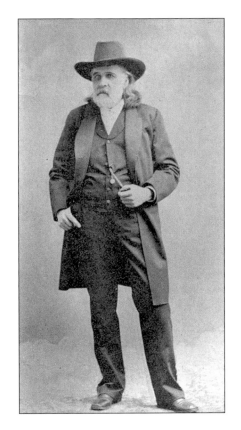

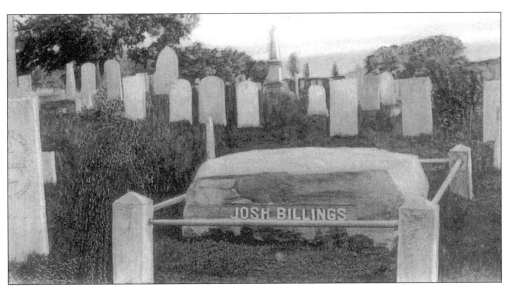

This 1908 postcard view of Josh Billings's grave is a testament to his continued fame decades after his death in 1885. For the past 25 years, the Great Josh Billings Runaground triathlon has been held annually in Berkshire County. Participants often paraphrase one of Billings's quotes by saying, "To finish is to win." (Author's collection.)

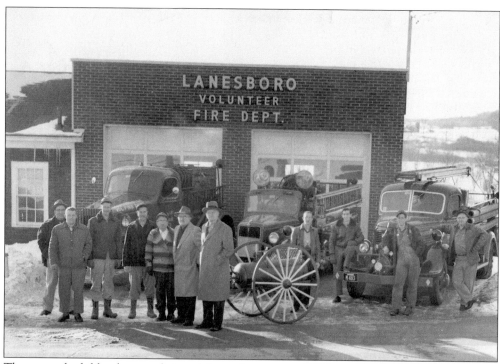

These men look like they need a good fire to keep warm. (William Tague photograph courtesy of the *Berkshire Eagle*.)

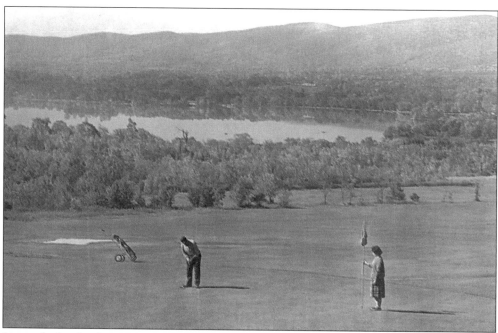

It must be hard to keep your eyes on the ball with scenery like this. These swingers are enjoying a few rounds at the Skyline Country Club. The water hazard in the background is actually Pontoosuc Lake. (Sam Scarfone photograph courtesy of the Berkshire County Historical Society.)

The Lanesborough Baptist Church was built in 1827 at the corner of Main and Summer Streets. It became the Federated Church in 1918. The building was demolished in 1983 after it was determined to be unsafe. A new church was constructed on the same site a year later. (Author's collection.)

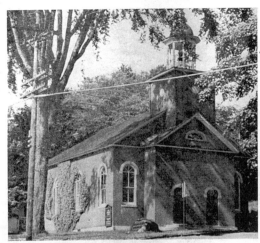

Include the Church in Your Vacation

Federated Church
(BAPTIST, CONGREGATIONAL, METHODIST)
Lanesborough, Massachusetts

Located at Junction of U. S. 7 and Route 502
(Opposite Lanesborough General Store)

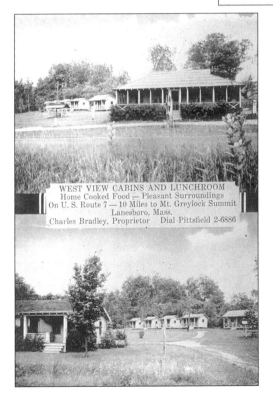

WEST VIEW CABINS AND LUNCHROOM
Home Cooked Food — Pleasant Surroundings
On U. S. Route 7 — 10 Miles to Mt. Greylock Summit
Lanesboro, Mass.
Charles Bradley, Proprietor Dial Pittsfield 2-6886

Let's pull in here and rest. The food is good and the view's not bad. (Courtesy of the Berkshire County Historical Society.)

Despite what folks might say, Washington did not sleep here. But rumor has it that this building leans to the right or left, depending on which political party controls Congress. The gravity-defying shack has become so famous that there is talk of changing "Lanesborough" to "Leansborough." (Author's collection.)

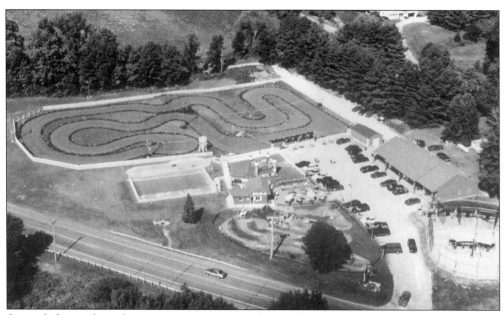

Some believe that the strange pattern in this field is proof that aliens have visited Lanesborough. Others suspect that the twisted track is for racing go-karts at the Par 4 Family Fun Center. If you look closely, you may also spot a miniature golf course and bumper boats. (Courtesy of Joanne Stevens.)

As sunlight reflects on an autumn maple, a young boy examines a single golden leaf. This magical moment was captured in 1956 at St. Luke's Episcopal church in Lanesborough. (William Tague photograph.)

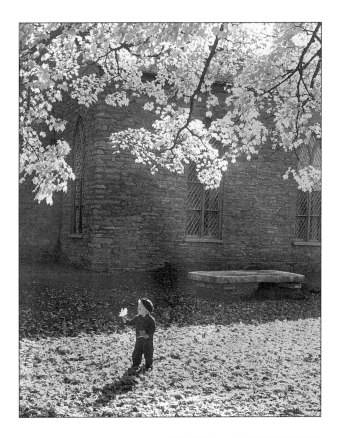

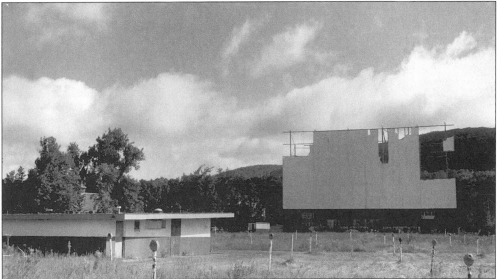

In 1948, Fred Cloutier and others opened the Sunset Park Auto Theatre in Lanesborough. For years, the drive-in was a popular spot to bring a date, and some of them even watched the movie. In the 1970s, the Sunset fell on hard times. For a while, there was talk of reviving the theater, but the deteriorating screen was eventually torn down. The End. Please remove the speaker from your car door before exiting. (Courtesy of the Lanesborough Town Hall.)

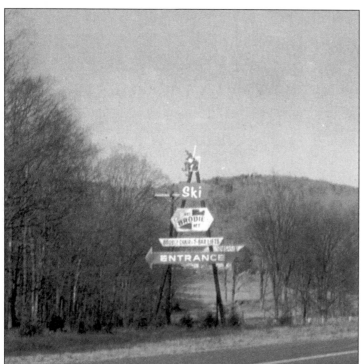

Brodie Mountain Ski Resort, also known as Kelly's Irish Alps, opened in the 1930s. This is how the entrance along Route 7 looked c. 1960. The rumor that they have green snow here is true, but it is always covered with white sheets before pictures are taken. (Courtesy of the Berkshire County Historical Society.)

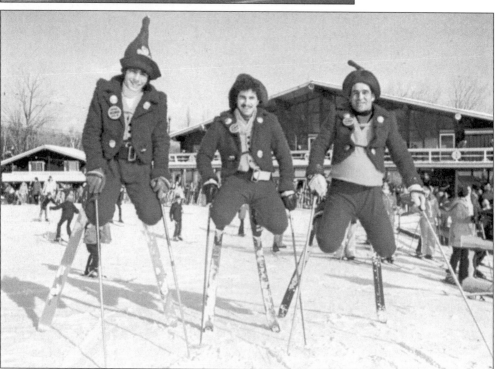

Even leprechauns need a vacation now and then. These three lucky charmers choose Brodie Mountain Ski Resort. Perhaps they left a pot of gold nearby. (Courtesy of the Berkshire County Historical Society.)

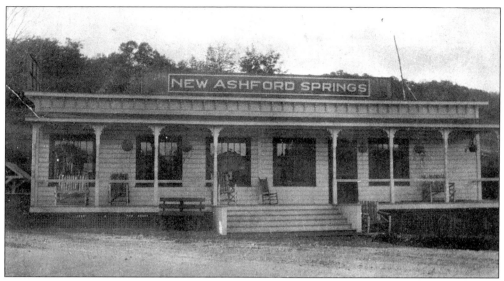

Mineral water connoisseurs have long considered the bubbling springs of New Ashford to have medicinal qualities. In the early 1900s, interest in the spring water gave rise to a small lodging house nearby. When the Grosso family acquired the lodge in 1930, they added a snack bar to serve the motoring public. Business was brisk and the snack bar was expanded. By the 1950s, the Springs Restaurant was known throughout New England for its fine dining. After a disastrous fire in 1975, the restaurant was rebuilt and is now known as the Mallory Steak House. (Courtesy of Ed Grosso.)

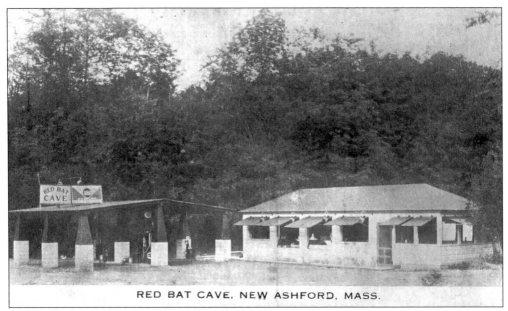

RED BAT CAVE. NEW ASHFORD, MASS.

During the first half of the 20th century, this New Ashford hole-in-the-ground attracted its fair share of the Route 7 tourist trade. The roadside oddity was ahead of its time in one respect—notice the rain canopy over the gas pumps. Red Bat Cave is now on private property and is off-limits to would-be spelunkers. Besides, the bats inside are now so old that their red heads have turned gray. (Author's collection.)

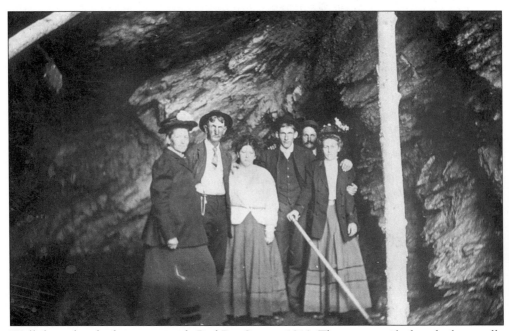

Well-dressed spelunkers pose inside Red Bat Cave c. 1910. They can testify that the bats really do have red heads. (Alfred Beach photograph courtesy of Ed LeFebvre.)

114

From the 1950s until the 1970s, Jack and Roberta Ryan operated the Spruces, a friendly tourist camp in New Ashford. This photograph was taken in 1952. When Route 7 was rebuilt in the 1960s, the road was shifted west onto the Ryans' property. Their former Esso gas station was moved back up the hill and became a gift shop. Today, the building serves as a popular yard sale stop on weekends during the summer. (Courtesy of Roberta Ryan.)

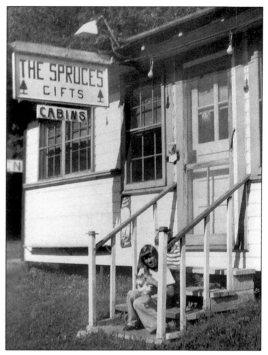

When women got the right to vote in 1920, New Ashford was already famous as the first town in the nation to cast its votes and announce the results. It was here in this New Ashford schoolhouse during the presidential election of 1920 that Phoebe Jordan became the first woman in the United States to legally place her ballot into the voting box. (Apparently, a woman in Ohio was technically the first to vote by filing an absentee ballot.) Nearly a half century earlier, Berkshire native and suffragette Susan B. Anthony was the first woman to vote illegally in New York and was later arrested. (Author's collection.)

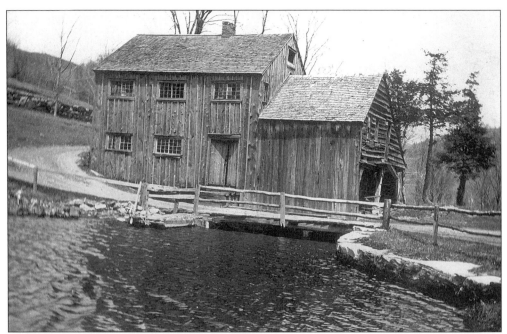

This is New Ashford's original Mill on the Floss, from which the restaurant next door takes its name. It is unlikely that the expression "floss after eating" originated here. (Alfred Beach photograph courtesy of Ed LeFebvre.)

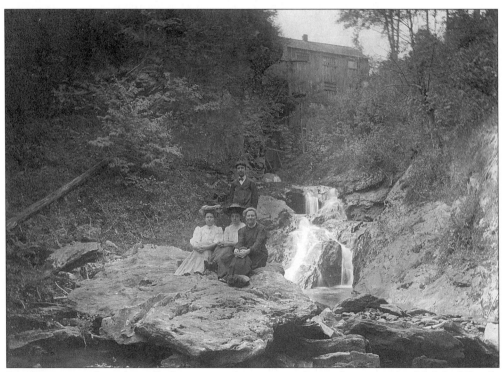

Just downstream from the mill, these nature lovers enjoy the soothing sounds of Ashford Brook. Just hope the dam holds. (Alfred Beach photograph courtesy of Ed LeFebvre.)

Nine

ENTERING

WILLIAMSTOWN

This lovely Berkshire visitor must have found what she was looking for at the 1753 House. The photograph was taken in 1956, and the cabin was built 1953 with materials and tools used in the mid-1700s. The house is located in Field Park, at the intersection of Routes 7 and 2 East. (William Tague photograph courtesy of the Williamstown House of Local History.)

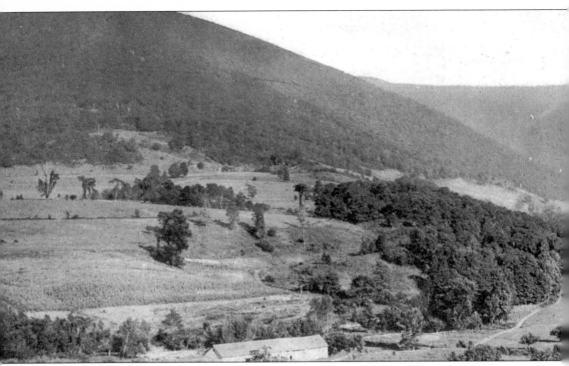

One of the most beautiful views to be found along Route 7 is shown in this panoramic photograph. Taken in the early 1900s, the South Williamstown scene remains surprisingly unchanged today. The Hopper, a glacial valley that resembles a grain hopper, is shown at the

This is the Samuel Sloan Tavern in South Williamstown as it appeared in the early 1900s. It is said that a portion of the building dates back to the 1700s. Known for many years as Steele's Store, it is now the Store at Five Corners. There used to be a lot more corners, but they were sold to tourists a long time ago (only kidding). (Courtesy of the Williamstown House of Local History.)

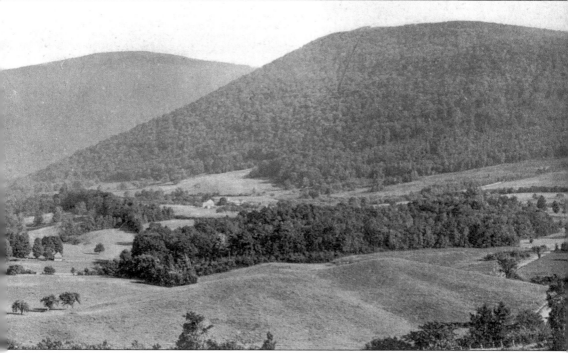

base of Mount Greylock, the tallest mountain in Massachusetts. (Courtesy of the Williamstown House of Local History.)

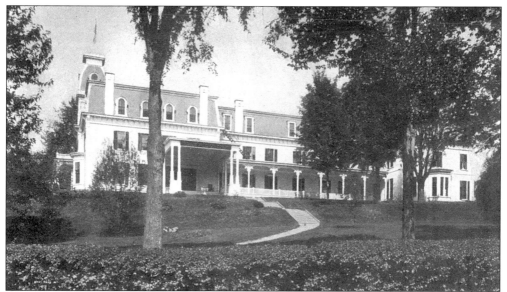

Perched upon on a hill in South Williamstown, this impressive building was first known as the Greylock Institute, a highly respected preparatory school. By 1895, it had become the scenic Idlewild Hotel. Although the hotel was popular with the carriage trade, business seemed to slow with the advent of the automobile. By the end of World War I, the hotel had closed. The deserted structure was torn down in 1932. (Courtesy of Judy Rupinski.)

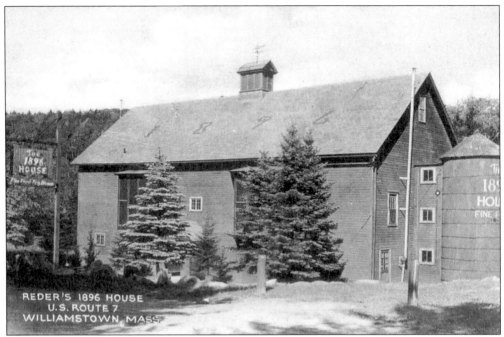

The Bullock Farm barn, known today as the 1896 House, was originally a machine shop that made valves. For a good portion of the 20th century, it has been a restaurant and motel. There is no truth to the rumor that the round structure on the right is a top-secret missile silo. (Author's collection.)

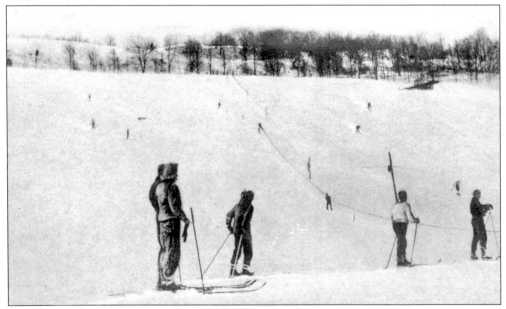

This modest ski slope on the west side of Route 7 was known as Sheep Hill. Actually, it was called Bee Hill until the Williams College Outing Club started skiing there. The real Sheep Hill (the one with all the sheep on it) was located down the road. So why did the students switch names? No one knows for sure—after the perpetrators fleeced the sheep, they went on the lam. (Courtesy of the Berkshire County Historical Society.)

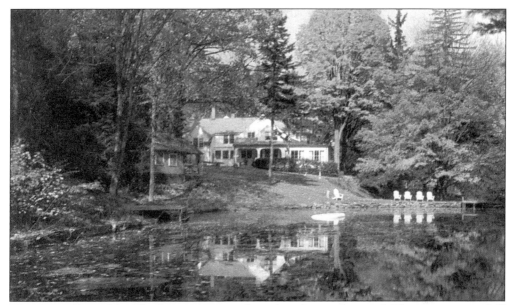

The tranquillity of the Elwal Pines Inn is reflected in the nearby pond. The inn sits on a hill overlooking Route 7 and is known today as Le Jardin Restaurant. (Courtesy of the Berkshire County Historical Society.)

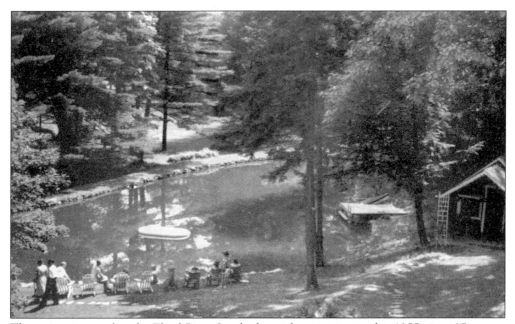

The swimming pool at the Elwal Pines Inn looks mighty inviting in this 1955 view. (Courtesy of the Berkshire County Historical Society.)

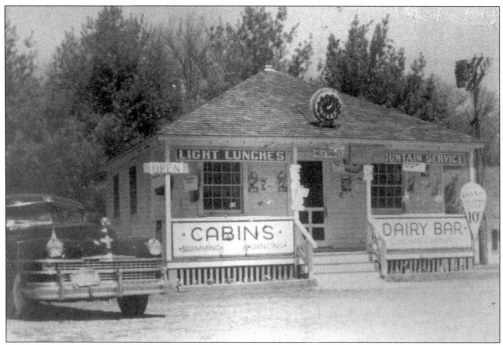

Abe's Snack Bar, with cabins and a swimming pool, was originally part of Taconic Park, located at the intersection of Route 7 and the Taconic Trail (Route 2 West). Remember—if you eat anything, be sure to wait 20 minutes before going into the water. (Courtesy of the Williamstown House of Local History.)

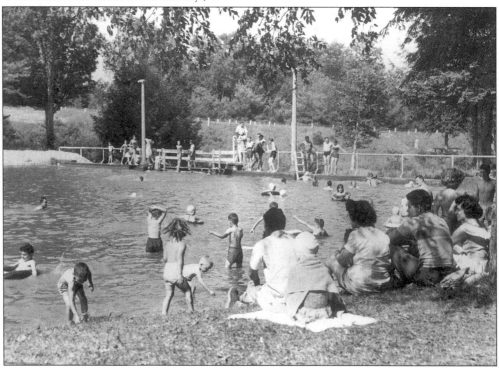

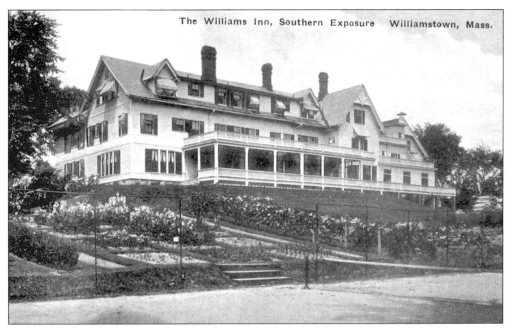

The Williams Inn was one of the best places in town to sit back, relax, and catch some rays. Because of its close proximity to Williams College, the hotel was popular with parents, visitors, and alumni. In 1974, the inn was converted into the first women's dormitory on campus. It is known today as Dodd House. (Courtesy of the Berkshire County Historical Society.)

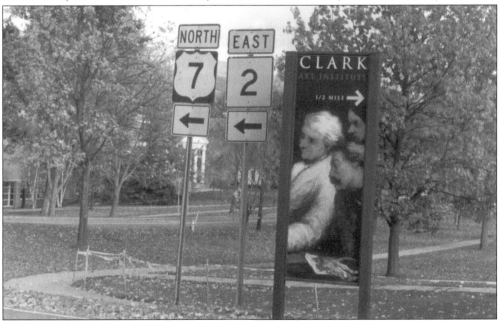

Where else but Route 7 would you find a street sign displaying the work of 19th-century French painter Daumier? The arrow points to the Clark Art Institute, a world-renowned museum and research center with an amazing collection of 19th-century European and American art, Old Masters paintings, English silver, and a growing collection of early photography. (Author's collection.)

123

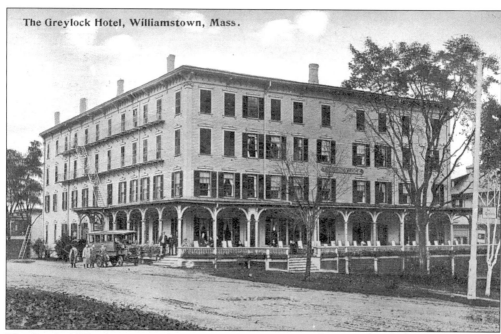

The Greylock Hotel, Williamstown, Mass.

The Greylock Hotel was opened in 1873 on the western edge of Williams College, near Route 7. The hotel was not very successful until Henry Teague bought the place. Teague was an advertising genius who marketed his hotel (and the entire village) with great success. Unfortunately, the Great Depression slowed business considerably, followed by a series of other misfortunes. The hotel was closed and was later torn down to make room for a Williams College expansion project. (Courtesy of Judy Rupinski.)

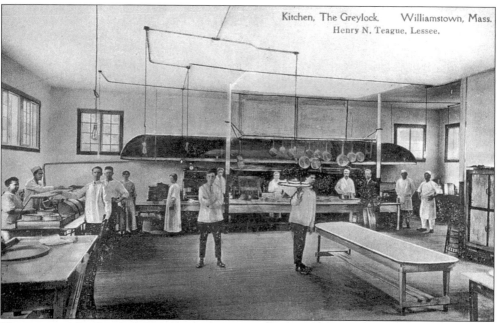

Kitchen, The Greylock. Williamstown, Mass.
Henry N. Teague, Lessee.

The owner of the Greylock Hotel was so proud of his modern, spacious kitchen that he made a postcard of it. So when do we eat? (Courtesy of Judy Rupinski.)

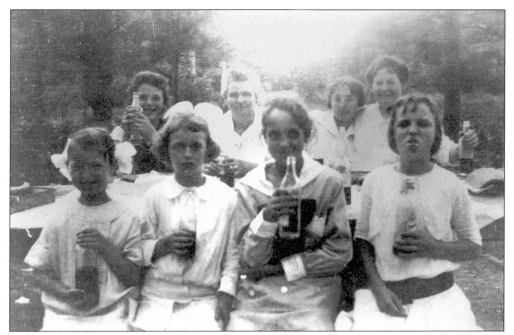

There is nothing like the refreshing taste of Williamstown's Sand Springs ginger ale to put a smile on your face. The young lady on the right must be drinking a discount brand. Sand Springs was best known for its mineral water pools, reputed to restore one's health and vitality. (Courtesy of the Williamstown House of Local History.)

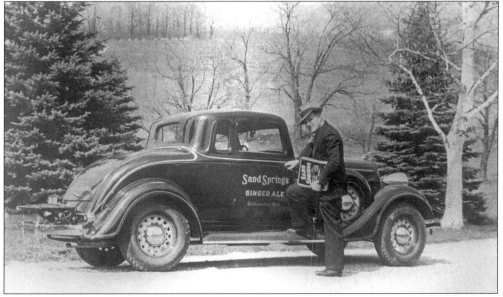

Sand Springs beverage sales slumped after Prohibition was repealed. This effervescent fellow is heading out to drum up some business. (Courtesy of the Williamstown House of Local History.)

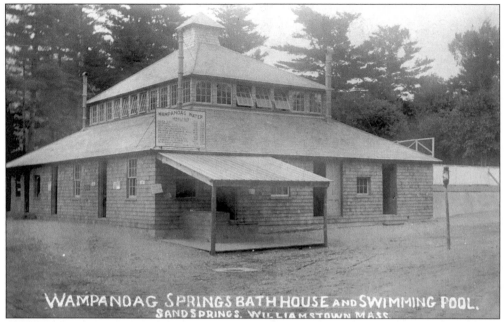

The sign on the front of this building gives a detailed analysis of the minerals in the medicinal swimming pool at Wampanoag Springs. The pool was part of the Sand Springs complex. (Courtesy of Judy Rupinski.)

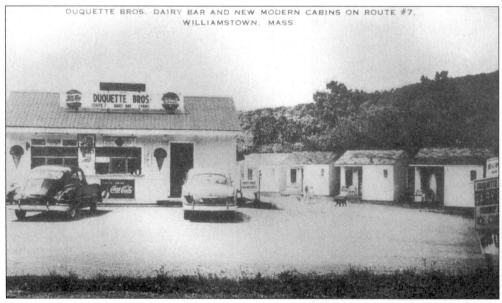

If you prefer milk to mineral water, then Duquette Brothers Dairy Bar is the place for you. The roadside rest stop, located north of Williamstown, welcomed travelers heading to and coming from Vermont. (Courtesy of the Williamstown House of Local History.)

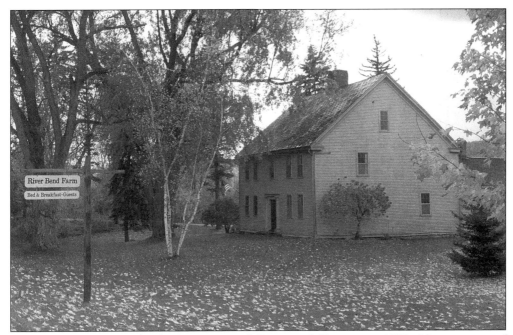

Benjamin Simonds established River Bend Farm and Tavern c. 1770. He was one of Williamstown's first settlers. He served as a colonel in the Revolutionary War and was commander of Massachusetts forces at the Battle of Bennington. The home is now a bed and breakfast just north of the Hoosic River. (Author's collection.)

These Hollywood celebrities were recently spotted shopping at Chenail's Farm Store on Route 7. None of them were willing to sign autographs. (Author's collection.)

Always be prepared for the unexpected when traveling on Berkshire Route 7. This attention-getting advertisement for Berkshire Hosiery was created by Ann Anda, Judy Schiebert, and Hugh Kretschmer for the Mayer/Berkshire Corporation. (Courtesy of Michael Mayer.)